POSTCARD HISTORY SERIES

River Towns of the Delaware Water Gap

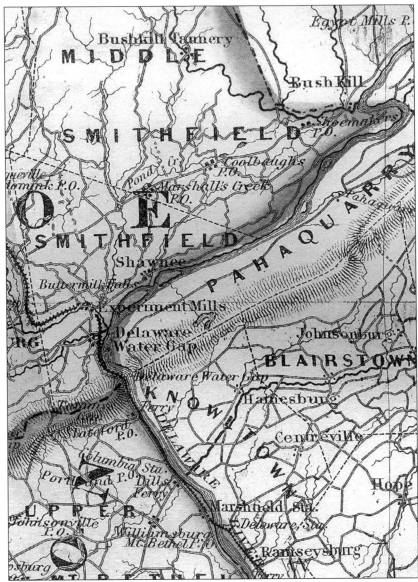

The Delaware River valley offered a natural playground for vacationers in an era that was born at the end of the American Civil War, reached maturity during the Victorian era, and died in the throes of the Great Depression. In accommodations ranging from grand hotels to modest farmhouses, weary city folk by the thousands were refreshed and entertained in the geographical area bordered by Northampton and Monroe Counties in Pennsylvania and Warren County in New Jersey, which lay within or immediately adjacent to the natural geologic wonder famously known as the Delaware Water Gap. This map is from an undated atlas of Pennsylvania. (Authors' collection.)

On the front cover: Please see page 22. (Authors' collection.)

On the back cover: Portland, Pennsylvania, was typical of the small villages that dotted both banks of the Delaware River within the shadow of the famous Delaware Water Gap and built a thriving tourist business based on the "Eighth Wonder of the World." (Authors' collection.)

POSTCARD HISTORY SERIES

River Towns of the Delaware Water Gap

Don Dorflinger and Marietta Dorflinger

ARCADIA
PUBLISHING

Published by Arcadia Publishing
Charleston SC, Chicago IL, Portsmouth NH, San Francisco CA

Printed in the United States of America

Library of Congress Control Number: 2008936311

For all general information contact Arcadia Publishing at:
Telephone 843-853-2070
Fax 843-853-0044
E-mail sales@arcadiapublishing.com
For customer service and orders:
Toll-Free 1-888-313-2665

Visit us on the Internet at www.arcadiapublishing.com

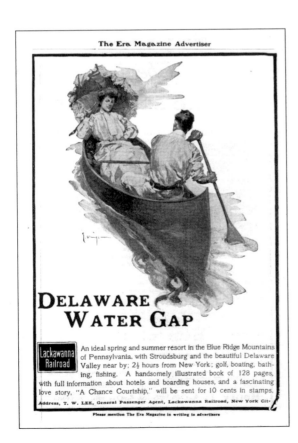

The Delaware, Lackawanna and Western Railroad was the funnel that served the Delaware Water Gap and cashed in on this by operating first-class service from New York City and its suburbs to the local hotels. Philadelphians could sample the gap's wonders by taking the Pennsylvania Railroad, which operated on its own Belvidere–Delaware division between Trenton and Manunka Chunk, New Jersey, and then used rights over the Delaware, Lackawanna and Western from that point to East Stroudsburg, Pennsylvania. Idyllic advertisements, such as this one that appeared near the dawn of the 20th century in the *Era* magazine, beckoned honeymooners to enjoy the soothing delights of a canoe ride on the Delaware River. (Authors' collection.)

CONTENTS

ACKNOWLEDGMENTS

The idea for a book about the river towns of the Delaware Water Gap germinated following the publication of our first Arcadia edition, *Orange: A Postcard Guide to Its Past*, in 1999. We had been collecting Delaware Water Gap postcards for some time, and the opportunity presented itself to purchase three major Pennsylvania collections. Had it ended there, the book might have focused only on the Pennsylvania side of the Delaware River. But in 2007, a Blairstown, New Jersey, historian decided to part with his postcard collection . . . one that focused primarily on the towns of the Delaware's New Jersey side. With the missing pieces now in place, it was time to create a historical tribute to an entire region of villages and hamlets, most of which would not have merited a complete book of their own. The link between all of them was the summer tourist industry, driven by the railroads and trolley lines that served the area, but it is important to remember that the residents still had to survive for the other seven months of the year in a generally agrarian society.

As our project moved forward, local experts came forward to help with the historical interpretation. Our thanks go out to Ruth Hutchinson Gommoll, whose family operated the Delawanna Hotel in Delaware, New Jersey, and who was happy to tirelessly share history and information; Barrett Transue, the historian of Portland and Slateford, Pennsylvania, who seemed well equipped to answer just about every question we might ask; Carl Schuster and Jon Bellis from the Knowlton Historical Commission; Tom Foley, whose family built and operated the Hotel Reenleigh and who was helpful in pinning down locations for many of the smaller hotels; Marty Wilson, professor of history at East Stroudsburg University and historian of the Antoine Dutot Museum in Delaware Water Gap, who was kind enough to proof the text and correct any historical errors; Erin Vosgien, our editor at Arcadia Publishing, who was great to work with; and Nancy and Steve Knott, landlords at our antique business in Portland, who always seemed to know where to steer us when we needed some direction.

We would like to dedicate this work to our mothers, Viola Dorflinger and Eleanor Pizzi, who would have enjoyed an ice-cream cone and Nedick's Orange Drink at the Bear Stop.

All images in this publication are from the authors' collection.

INTRODUCTION

Ah, the Delaware Water Gap. It is the place where the ancient river first seen by the Lenni-Lenape Nation cuts a deep swath through the formidable barrier of the Kittatinny and Blue Mountains, carving out Mount Minsi on the Pennsylvania side and Mount Tammany and Mount Blockade on the New Jersey bank. Writers have lauded its wonders, poets have memorialized it, and painters and photographers have captured its ageless beauty. But it was the publicists who reinvented it as the "Eighth Wonder of the World" and a "must-see" vacation destination, and the masses came. They came as early as 1829, when Antoine Dutot, founder of the village of Dutotsburg, later to become the town of Delaware Water Gap, constructed the first rudimentary version of the Kittatinny House. But the six decades following the American Civil War were its halcyon days. Vacationers came by way of the railroads that were built through the gap in 1856 and 1882. They came by way of the trolleys that arrived in 1906 at the height of the interurban era. And they came by automobile, ironically the vehicle that would both make the gap easily accessible by 1910 and bypass it by 1930 in favor of the newer and more attractive resorts of the Pocono Mountains and beyond.

A summer trip to the gap at the dawn of the 20th century was a family adventure, starting at the local city railroad depot in the environs of New York City or Philadelphia and culminating, for those who could afford it, in a full summer at a major hotel like the Kittatinny House or Water Gap House. The less affluent might spend a week at one of the smaller boardinghouses either at the gap or in one of the neighboring hamlets.

The adventures seem tame by today's standards: swimming in the river; moonlight cruises on the launch operated by the Kittatinny; canoeing the river or on Lake Lenape; horseback and burro riding; croquet, golf and tennis; hiking the many trails prepared by the hotels to reach obscure locations with wistful names like Diana's Bath or Caldeno Falls; dances and cakewalks; band and orchestra concerts; and bridge and whist tournaments.

While it is difficult to assign a high-water mark for tourism at the gap, the decade prior to the United States's entry into World War I might fit the bill as well as any. It also may be the era best documented, for it was during this time that the picture postcard flourished. Vacationers at the gap sent these delightful gems home to friends and relatives to prove without a doubt that they were rubbing elbows with the rich and famous . . . or at least visiting Lamb's or Hauser's stores to spend a few pennies to make those left at home envious.

The quality postcards were manufactured in Germany, and World War I put an end to their importation, forcing vendors to settle for inferior-quality views produced elsewhere. More important, the war created a downturn in the tourist industry. In the postwar Roaring

Twenties, any potential resurgence was blunted by the family automobile that now carried hearty vacationers over an ever-burgeoning highway system past the gap to the wonders of the Pocono Mountains and beyond. Fire gradually claimed a number of hotels and boardinghouses, and as they disappeared, they were not rebuilt. In 1929, the Great Depression struck, causing financial upheaval, with much of it targeting the economic level of clientele that patronized the grand hotels. The following year, the great concrete highway, the Lackawanna Trail, was completed north through the Delaware Water Gap to the Pennsylvania Poconos and Binghamton, New York, putting other vacation destinations within easy reach. The gap and its neighboring villages, all fighting for a slice of the once lucrative but now skeletal tourist pie, reverted to a lazy sleep.

The postcard views in this book are from the authors' personal collection and highlight the decade from 1906 to 1916, when thousands of vacationers took time out from their busy schedules to hop a train or trolley and enjoy, if only for a short time, the fresh air and natural and man-made wonders of the Delaware Water Gap and its surrounding river towns.

One

GETTING THERE
THE TRAINS AND TROLLEYS

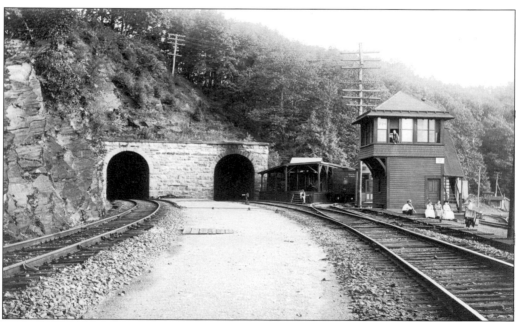

Vacationers escaping sweltering cities along the Delaware, Lackawanna and Western Railroad (Lackawanna) got their first glimpse of the Delaware River at Manunka Chunk, New Jersey, as their train emerged from the west portal of Vass Gap tunnel. Completed in 1856 as a part of John I. Blair's Warren Railroad, Manunka Chunk later became a junction with the Pennsylvania Railroad's Belvidere–Delaware division (at right), which used operating rights over the Lackawanna to run passenger trains from Philadelphia to the Delaware Water Gap from 1909 to 1952. The wooden tower at the right controlled the signals and switches at this location and was designated as U–774, marking the distance from Hoboken, New Jersey, to this important place (77.4 miles).

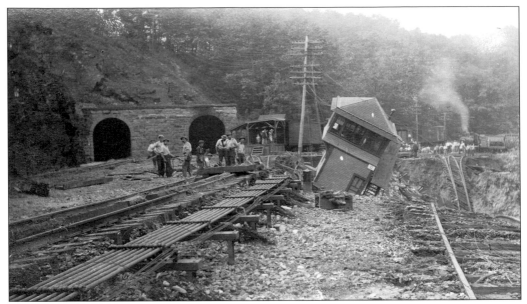

On August 1, 1913, six inches of rain soaked Manunka Chunk, New Jersey, in three hours. Catherine's Run, a normally docile stream at the east end of the tunnels that was diverted under the tracks through a wooden flume, overflowed its banks and cascaded through the tunnels and off the hillside at the west end, causing extensive erosion. Tower U-774 was undermined and would have toppled over had it not become snagged on a communication line. Railroad crews worked feverishly and restored limited train service by the following evening.

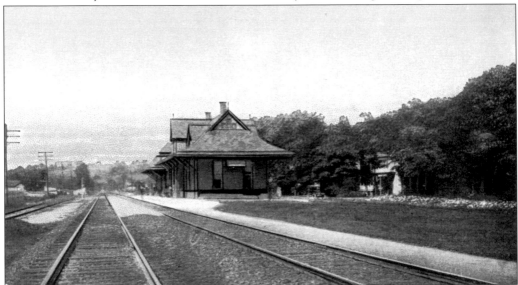

Delaware Station, New Jersey, was the first stop westbound in the Delaware River valley, and the depot opened in July 1856. In 1876, railroad tycoon John I. Blair built the Blairstown Railway from his namesake village to connect with the Lackawanna here. The New York, Susquehanna and Western Railroad (Susquehanna) absorbed Blair's short line in 1882 as it built west to the Pennsylvania coalfields. In 1911, the Lackawanna completed its New Jersey Cut-Off, bypassing Delaware Station and downgrading the old line, which was finally abandoned on April 21, 1970. The station was razed in February 1968.

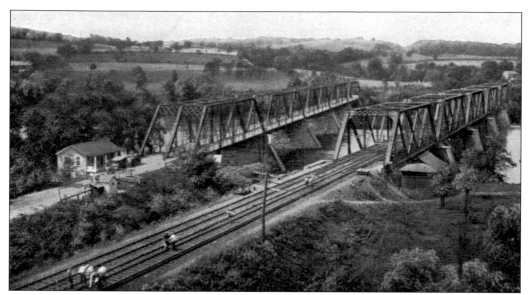

Two bridges crossed the Delaware River into Pennsylvania north of the village. The iron structure on the left was the second railroad bridge at this site and was built in 1871 to replace the original wooden span. Heavier locomotives necessitated construction of the stronger steel bridge on the right. The iron bridge was then purchased by the Reverend Henry Darlington and his Knowlton Turnpike and Bridge Company, which operated it as an automobile toll crossing until it was purchased by the Delaware River Bridge Commission for $275,000 and freed. The highway bridge was closed on April 3, 1954, and demolished, but the railroad bridge still stands.

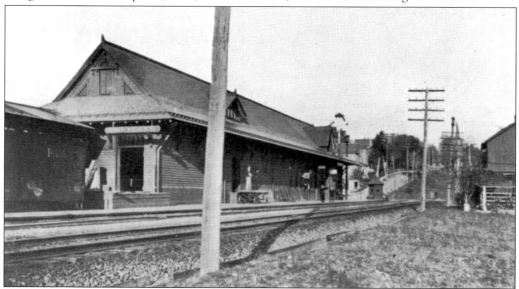

Blair's attempt to create another town at Marshfield, Pennsylvania, one mile south of Portland, Pennsylvania, quickly failed, and the latter became the first major station in the commonwealth. Enos Goble owned the land and was a major factor in raising subscriptions for the erection of a depot in 1857. Appropriately, Goble was appointed the first agent. Portland boasted a stockyard, a water tower, an interlocking tower, and a connection with the Bangor and Portland Railway, later also part of the Lackawanna. Like Delaware, Portland was also bypassed by the New Jersey Cut-Off in 1911.

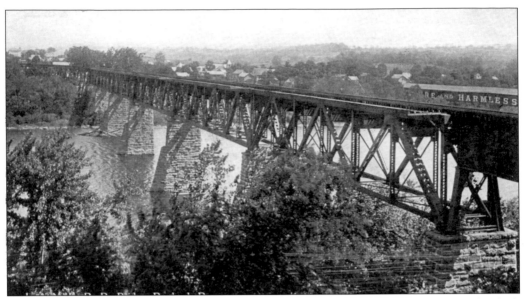

Portland, Pennsylvania, was also served by trains of the Lehigh and New England Railroad, which entered the town from Columbia, New Jersey, via this impressive bridge over the Delaware River. The original span was completed by predecessor Pennsylvania, Poughkeepsie and Boston Railroad in 1889. The Lehigh and New England absorbed the bankrupt Pennsylvania, Poughkeepsie and Boston in 1894 and rebuilt the bridge in 1908. The Portland–Columbia covered bridge is just visible to the right, and the advertisement for Sozodent painted on the side dates the view to the early 1900s.

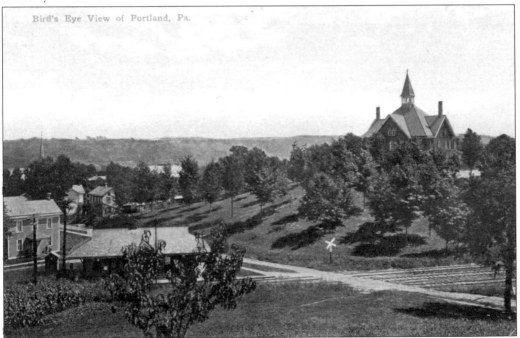

The Lehigh and New England Railroad station in Portland (lower left) stands at the top of Main Street below the knoll, which houses the school (upper right). Although the tracks are long gone today, the station survives, and the school is now the Portland municipal building.

12

With no stop scheduled north of Portland at Slateford, Pennsylvania, a Lackawanna express train rolls through Point of Gap, hustling excited vacationers to the next station in the town of Delaware Water Gap, Pennsylvania. Mount Tammany watches over the scene in the background. The locomotive is a camelback type, with the engineer's cab straddling the boiler while the fireman shovels coal under a rear canopy. The narrow dirt road at the right is the ancestor of today's busy Route 611.

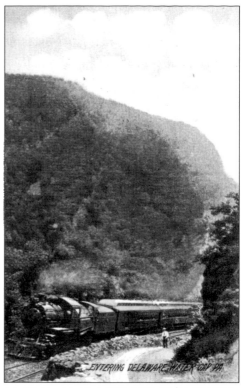

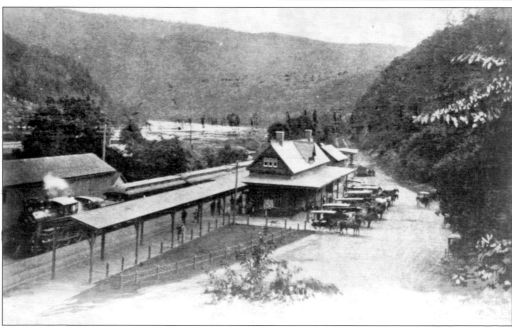

The original Lackawanna depot at Delaware Water Gap was made of wood and burned down in a spectacular fire on October 30, 1902. Here it is in its glory days with horse-drawn taxis and carriages lined up and ready to take the latest arrivals to their respective hostelries. Larger hotels like the Kittatinny House and Water Gap House had their own conveyances that met every train. For the smaller boarding facilities, advance notice of arrival was required.

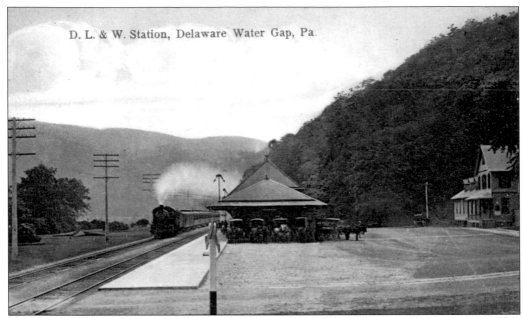

The replacement station, which opened on April 28, 1904, was constructed of fireproof brick at a cost of $20,000. The building to the right is the Delaware House, which stood directly across the street from the depot and needed no conveyances to transport its guests. The depot was named Water Gap until 1941 when it became Delaware Water Gap. In its peak years, the station handled several thousand visitors daily.

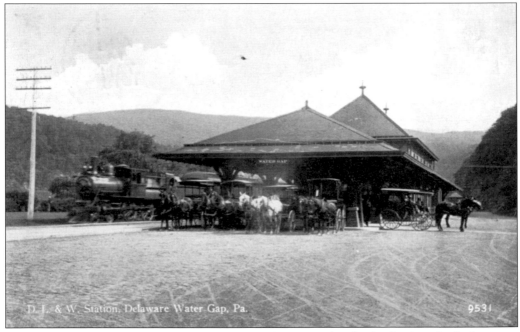

D. L. & W. Station, Delaware Water Gap, Pa.

9531

The *Limited* seems impatient to have its passengers detrain as it has further business in the Poconos. Six carriages await the guests and their luggage. Each hotel and omnibus had a designated spot to wait, so if one thinks that this view might have been taken the same day as the previous one (because of the position of the team of white horses), it is possible, but not necessarily true.

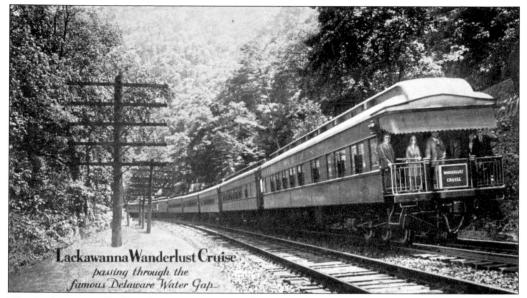

Lackawanna Wanderlust Cruise
passing through the
famous Delaware Water Gap

The Lackawanna Railroad was a pioneer in the excursion business and enjoyed a reputation for being passenger friendly. An open platform observation car brings up the rear of this Lackawanna Wanderlust Cruise as it rolls through the Delaware Water Gap about 1930. Ironically, the railroad that helped fuel the gap's resort industry was now transporting passengers right through it to more exotic destinations in the Pocono Mountains. It was not long before the automobile had the same effect on the railroad.

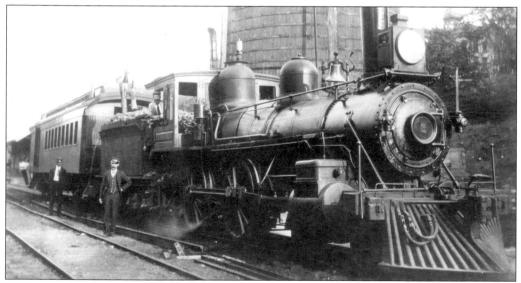

The other railroad to enter the Delaware Water Gap was the Susquehanna, which ran via Columbia and Dunnfield, New Jersey, on the east shore of the river. In this view, Susquehanna No. 2, formerly Blairstown Railway No. 2, poses at Blairstown, New Jersey, ready to take its local accommodation to meet a Lackawanna train at Delaware Station, New Jersey. The Susquehanna entered the passenger market in October 1882, but it only tapped a small portion of the Delaware Water Gap business. It focused more on freight, hauling coal out of the Wilkes-Barre, Pennsylvania, area and ice and huckleberries from the Poconos via its subsidiary, the Wilkes-Barre and Eastern Railroad, which was completed in 1893.

15

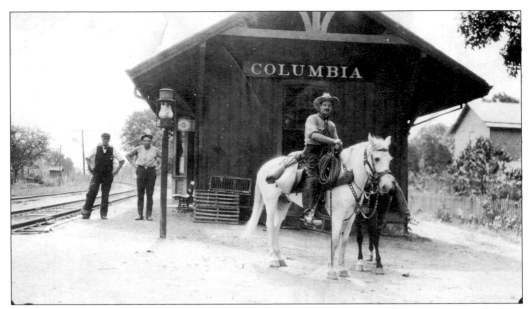

The Susquehanna absorbed the Blairstown Railway between Blairstown and Delaware Station, New Jersey, but forged its own new line north through the Delaware Water Gap, branching off Blair's railroad just east of the village of Columbia, New Jersey. Here is the Susquehanna's Columbia, New Jersey, station in all its glory about 1921, as a local cowboy prepares to rough it in the gap on horseback with a pack animal to carry his supplies. The agent and baggage man pose at the left.

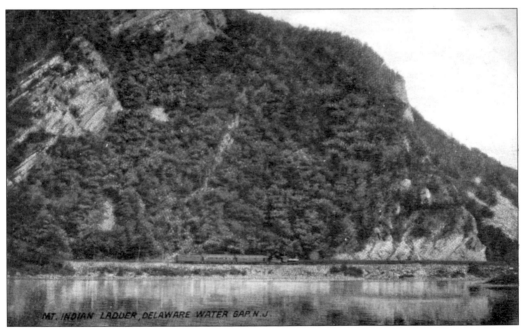

In this rare early view, the Susquehanna mixed train from Stroudsburg, Pennsylvania, rolls east below the Indian Head Ladder on the New Jersey side of the river as it prepares to slow for its stop in Dunnfield, New Jersey. The line was abandoned in 1940, and the rails were removed and scrapped about 1942 for the war effort. Route 80 occupies much of the right-of-way through the gap in New Jersey today.

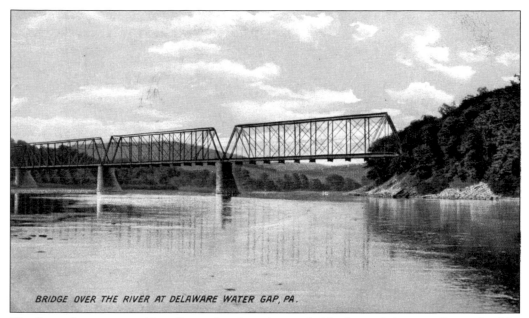

BRIDGE OVER THE RIVER AT DELAWARE WATER GAP, PA.

The Susquehanna crossed into Pennsylvania on its own bridge located about a mile north of the present Interstate 80 crossing. Its depot was actually located about a half-mile west of the bridge in the hamlet of North Water Gap (now Minisink Hills), Pennsylvania. In later years, the bridge was considered too rickety for more than one locomotive at a time, and certain heavier engines leased from its parent railroad, the Erie, were prohibited altogether.

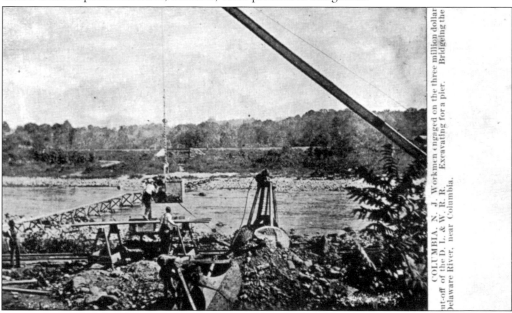

COLUMBIA, N. J. Workmen engaged on the three million dollar cut-off of the D. L. & W. R. R. Excavating for a pier. Bridging the Delaware River, near Columbia.

A major engineering project undertaken by the Lackawanna Railroad between 1908 and 1911 changed the face of the region forever. The New Jersey Cut-Off, a totally new railroad line designed to eliminate the mileage, curves, tunnels, and grades of the existing main line, was built between Port Morris, New Jersey, and Slateford, Pennsylvania, effectively bypassing the old route and its stations at Delaware, New Jersey, and Portland, Pennsylvania. Here preliminary work is beginning on the construction of the new Delaware River viaduct at Slateford.

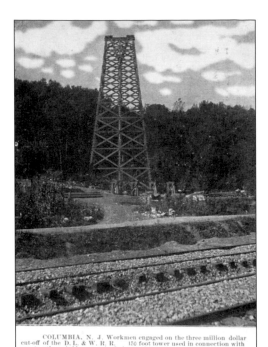

To effect construction of the viaduct, several towers were built to support a cableway that carried construction materials out over the river. In this view, the tower on the New Jersey side at Columbia has just been completed. The trackage in the foreground is the Susquehanna, which was overpassed with a concrete arch. The new line ran above the village of Columbia and no station was ever constructed there.

COLUMBIA, N. J. Workmen engaged on the three million dollar cut-off of the D. L. & W. R. R. 150 foot tower used in connection with constructing a bridge over the Delaware River, near Columbia

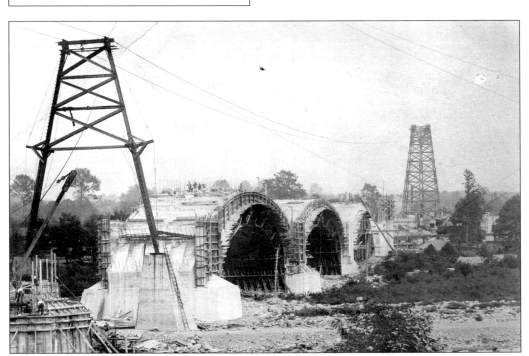

In this rare view, the wooden falsework for the first three arches of the Delaware River viaduct has just been completed, and the midstream cable tower can be seen at the left. The cableway was used to carry dump cars filled with concrete, which would be poured into the falsework mold to create the finished structure.

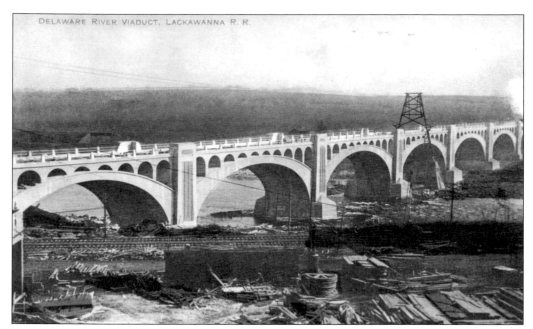

The viaduct is nearly complete in this 1911 view. The center tower of the cableway has yet to be dismantled, and discarded wooden falsework can be seen in the foreground. When the New Jersey Cut-Off opened on December 24, 1911, the old main line via Washington, New Jersey, was downgraded, and depots at Delaware, New Jersey, and Portland, Pennsylvania, fell back into a lazier existence, as fewer trains operated over the old route.

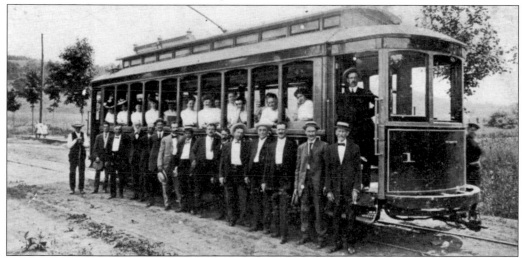

Trolley lines also served Delaware Water Gap, Pennsylvania, and its neighboring villages. The Stroudsburg Passenger Railway extended its tracks up Foxtown Hill and over Godfrey Ridge south to the village in 1907 as the Stroudsburg and Water Gap Street Railway. Delaware Water Gap councilmen pose with car No. 1, probably on July 3, 1907, when the first special trip operated. From left to right are unidentified, Ruben Staples, unidentified, Horatio Hauser, Luther Staples, unidentified, unidentified, Millard Hauser, Joseph Graves (photographer and publisher of water gap postcards), Grant Edinger, L. B. Palmer, unidentified, unidentified, N. N. Holbrock (Stroudsburg and Water Gap Street Railway president), and Samuel Overfield (owner of the Central House). Car No. 1 was built by the Brill Company in 1906.

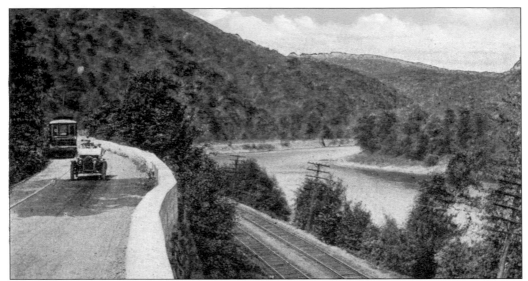

The Lehigh Valley Traction Company saw potential profits in operating through service from Philadelphia and invested $50,000 to extend the line south to Portland, Pennsylvania, in October 1911, as the Stroudsburg, Water Gap and Portland Railway. The interurban leased a right-of-way through the gap from the Lackawanna Railroad, which dynamited the hillside above its tracks on February 11, 1911, to widen the existing road to accommodate the trolley. Here, a Stroudsburg, Water Gap and Portland car shares the forerunner of today's Route 611 with a vintage automobile.

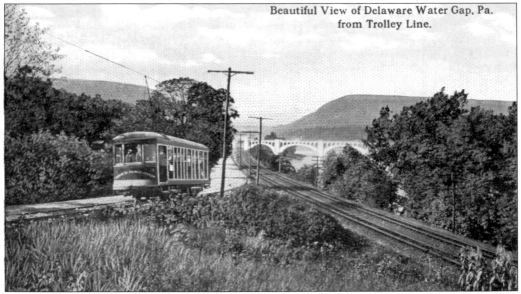

Beautiful View of Delaware Water Gap, Pa. from Trolley Line.

The Stroudsburg, Water Gap and Portland Railway reached its maximum extent at the crossing of the Lehigh and New England Railroad's tracks at the top of Delaware Avenue in Portland. The railroad refused the trolley rights to cross its tracks, so the cars terminated at the intersection of First Street. Here car No. 4, a center-aisle open car built by the Brill Company in 1911, rolls along Main Street (today's Slateford Road) bound for Stroudsburg, Pennsylvania. The Delaware Water Gap looms in the background as the trolley prepares to parallel the Lackawanna's old main line for the next mile. The new cutoff viaduct is visible at the center of the scene.

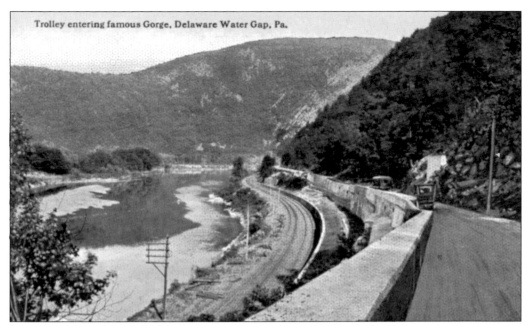

Trolley entering famous Gorge, Delaware Water Gap, Pa.

Another view of the majestic Delaware Water Gap, looking south along today's Route 611, shows a trolley about to pass a southbound automobile. The stretch of interurban track between Point of Gap and the Kittatinny Hotel was considered one of the most scenic in the country and thrilled area visitors throughout its short existence.

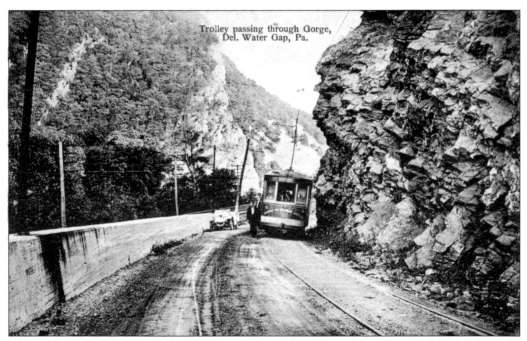

Trolley passing through Gorge, Del. Water Gap, Pa.

The conductor of car No. 5 takes a moment to pose for a Hauser's store postcard under the rocks at Point of Gap. The automobile at the left, which also appears in other Hauser views, probably belongs to the photographer. No. 5, a sister car to No. 4, was also a 1911 graduate of the Brill Company in Philadelphia and survived until the end of Stroudsburg city service in 1928.

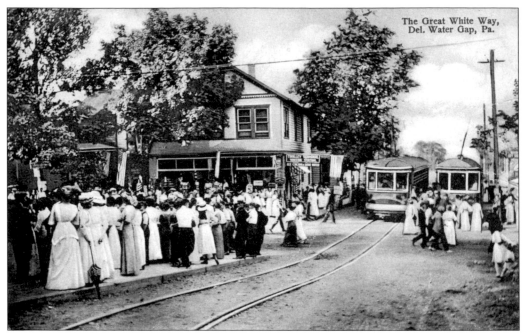

The Great White Way,
Del. Water Gap, Pa.

The trolley junction in the center of Delaware Water Gap, Pennsylvania, was always a busy place on summer afternoons. The junction was actually just a siding near the intersection of High Street and Delaware Avenue, where north and southbound trolleys could meet and pass each other. Hauser's souvenir store, which sold many of the postcard views seen in this book, stands at the left.

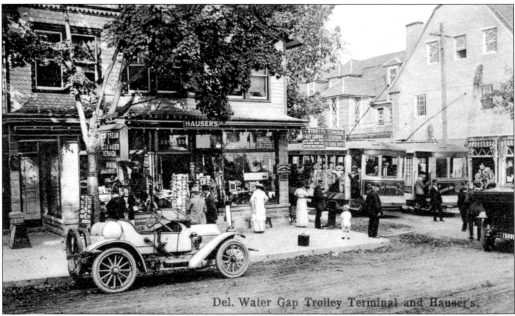

Del. Water Gap Trolley Terminal and Hauser's.

The ever-present photographer's car sits curbside in front of Hauser's as happy tourists scan the racks of postcards while trolleys No. 5 and No. 4 wait impatiently to depart. The Castle Inn is to the right. In the fall of 1926, the Lackawanna Railroad abruptly canceled the Stroudsburg, Water Gap and Portland Railway's right-of-way lease through the Delaware Water Gap, and the last trolley operated into Portland, Pennsylvania, on November 30.

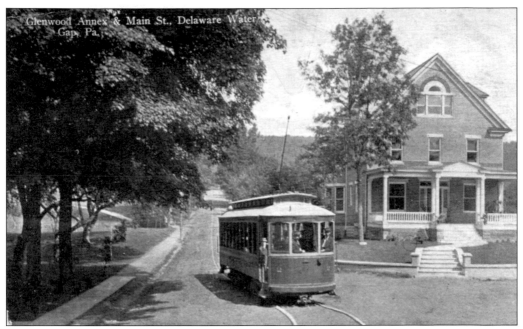

Car No. 2 rolls up Main Street in Delaware Water Gap past the Glenwood Hotel Annex as it trundles on its way toward Stroudsburg, Pennsylvania. Riders would now have an opportunity to view the gap from the top of Godfrey Ridge, which the trolley reached by way of a double horseshoe curve. The annex was formerly a guesthouse called the Del-Ray.

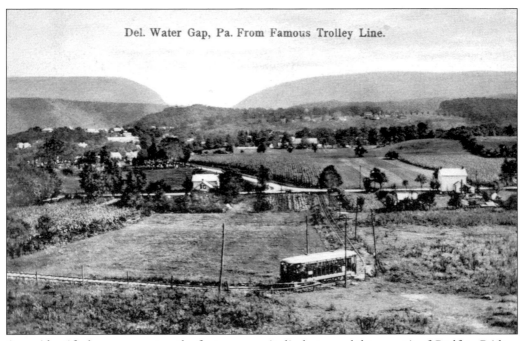

An unidentified open car enters the first curve, as it climbs toward the summit of Godfrey Ridge. Both the town and the natural wonder named Delaware Water Gap are visible in the background. The highway running across the middle of the view is today's Route 611.

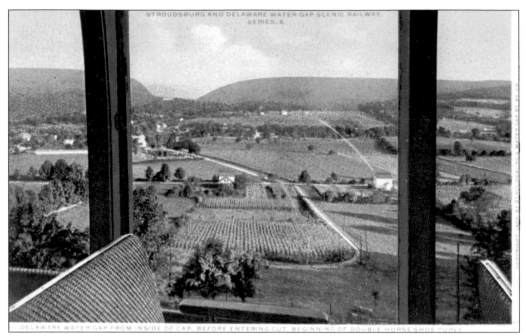

DELAWARE WATER GAP FROM INSIDE OF CAR. BEFORE ENTERING CUT. BEGINNING OF DOUBLE HORSE SHOE CURVE.

This is the way the passengers saw it from the car as they climbed Foxtown Hill in this rare view, one of eight in a series published as publicity for the trolley line. The interurban constructed a small overlook and pavilion on property owned by Preston Rinehart and always stopped briefly at Rinehart's Outlook to give the tourists a breathtaking view.

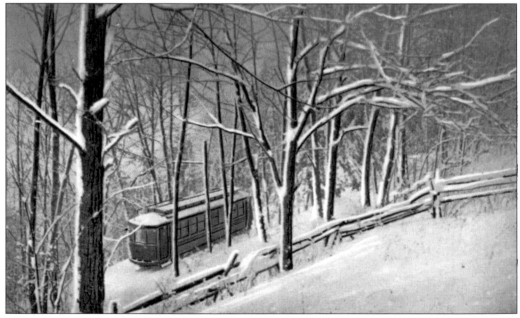

The trolley was an essential mode of transportation for the area, especially in winter when snow and ice made roads impassable. The trolleys also carried small lots of freight, such as packages and trunks, which often rode on the open platforms. In this bucolic scene, car No. 2 goes about its business in the midst of a blizzard, as it descends Foxtown Hill, perhaps carrying high school students between Delaware Water Gap and Stroudsburg, Pennsylvania.

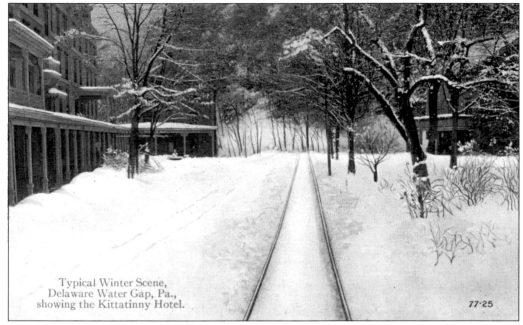

Typical Winter Scene,
Delaware Water Gap, Pa.,
showing the Kittatinny Hotel.

77·25

In another vintage scene, the photographer has assumed a position on the rear platform of the trolley as it passes the shuttered Kittatinny Hotel during a snowstorm of a long-ago winter. Even though the tourist season generally lasted only from April 1 to November 1, the trolleys ran year-round, serving the transportation needs of the residents of the Delaware Water Gap area.

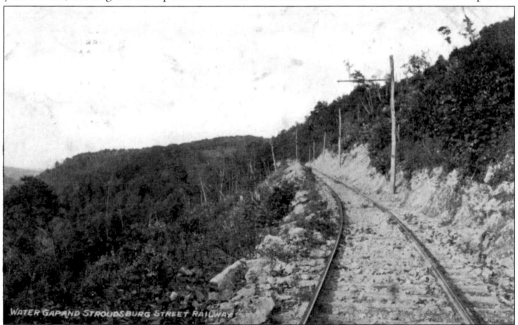

WATER GAP AND STROUDSBURG STREET RAILWAY

Here is a view from the vantage point of the motorman, as the trolley climbs toward Godfrey Ridge on its way to Stroudsburg. The Mountain View Company purchased the trolley operations out of Stroudsburg in 1917, and the route to Delaware Water Gap and Portland became known locally as the Mountain View Trolley Line. Service to Delaware Water Gap ended for good on September 4, 1928, and the tracks were abandoned and scrapped.

In this poignant photograph, two forlorn trolleys sit in the Stroudsburg, Pennsylvania, carbarn five years after service was discontinued. Although the photographer noted the number of the car at the left as No. 14 (Stroudsburg, Water Gap and Portland Railway never had a No. 14), it is probably No. 4, and the car to the right is No. 5. The proliferation of automobiles, motor trucks, and buses spelled doom for the interurban lines.

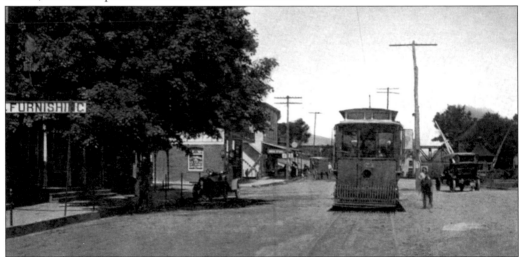

The Bangor and Portland Traction Company entered Portland, Pennsylvania, from the south, terminating at the Lackawanna depot. It was formed on May 26, 1904, from the consolidation of two smaller trolley lines and reached the city limits in the summer of 1905 after a lengthy battle with the Lackawanna Railroad's subsidiary, the Bangor and Portland Railway, over the right to cross their tracks. The Lackawanna finally allowed an underpass for the trolley at the Mount Bethel township line. The Lehigh Valley Transit Company operated through trolley excursions from Philadelphia to the Delaware Water Gap via Portland from 1912 until the end of the 1915 vacation season. The Philadelphia and Easton Electric Railway operated a similar service between 1908 and 1915, using transfers between existing lines. Its last leg between Portland and the gap used the Lackawanna trains.

Two

DELAWARE
JOHN I. BLAIR'S VILLAGE

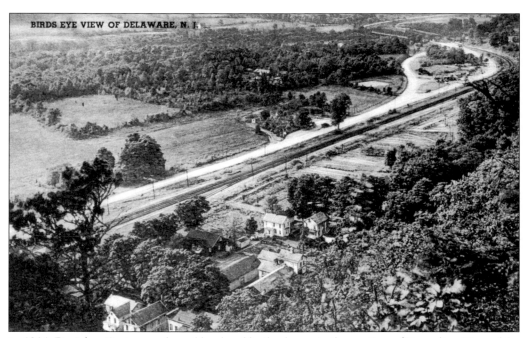

BIRDS EYE VIEW OF DELAWARE, N. J.

In 1816, Dr. Jabez Gwinnup cleared land and built a home in the portion of Knowlton Township, New Jersey, that became Delaware Station. But it was the railroad magnate John I. Blair who surveyed and laid out the village lots in 1856 on tracts of land adjacent to the Delaware River, which he had purchased from the Gwinnup and Cornelius Albertson families. The shrewd Blair, a land agent for the Lackawanna Railroad, knew that the completion of the line would inflate the value of his properties. Looking down from Blair's Knob, a portion of the village, the railroad, and today's Route 46 are visible. The village later simplified its name from Delaware Station to Delaware. A round trip to or from New York City in 1903 cost $3.15.

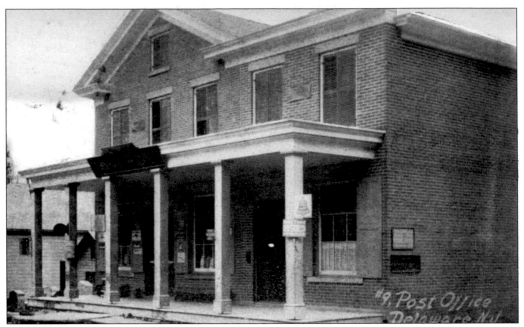

John I. Blair built this brick store in Delaware Station, New Jersey, in 1860 at the corner of Valley Road and Clinton Street and sold it just four years later to James Prall and his partner, John Wyckoff, who operated it for the next 25 years. The post office moved in shortly after it was completed. It claims the title today of being the oldest post office in New Jersey still operating out of its original location even though it briefly occupied at least one other store in the village before moving into Blair's building.

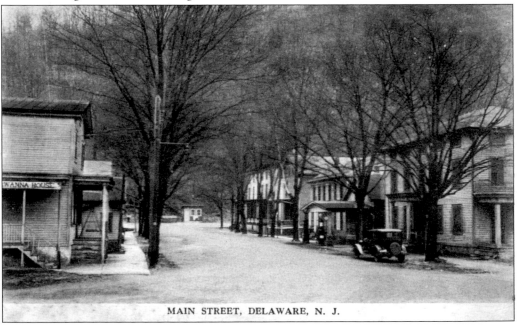

MAIN STREET, DELAWARE, N. J.

This view looks east from the Lackawanna station up Clinton Street toward Valley Street. The Lackawanna Hotel, built in 1860, stands on the left corner, and the Delaware House, constructed two years earlier, is just across the street to the right.

With the exception of the lush trees and the narrow dirt path, this view could have been taken yesterday, as the private homes here look much the same. This location is now the corner of Ann and Valley Streets, and local roads have been slightly modified, as at some point the street names were reversed.

A companion view, looking north from nearly the same location, shows Valley Street (then called Ann Street) much as it appears today. Valley Street becomes Delaware Street soon after it passes the home of Dr. Jabez Gwinnup, the last white house on the left. A short carriage ride past his house goes to Hutchinson's Mill and the Delawanna House hotel.

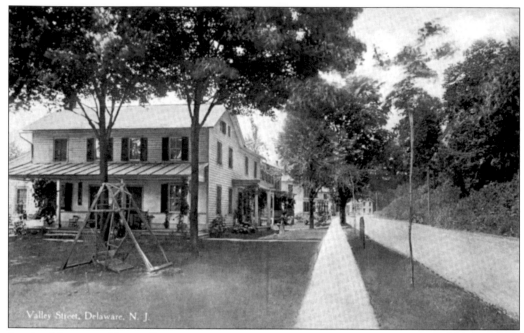

Valley Street, Delaware, N. J.

South of the post office, Valley Street is a residential area that seems stopped in time. The building to the left is the parsonage of the Delaware Presbyterian Church and was built by Cornelius Albertson in 1820 as a farmhouse. After John I. Blair bought Albertson's land for the construction of the Lackawanna Railroad, he donated the house to the church. The front porch rockers, the garden swing, the hitching post, and the sun dial all attest to an easier lifestyle.

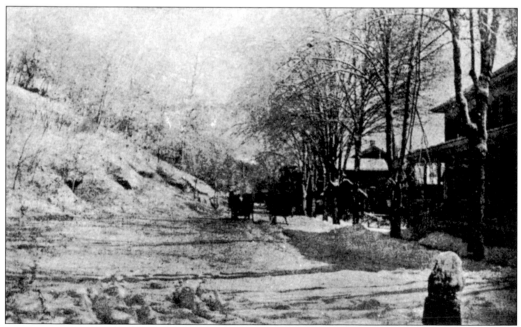

Valley Road presents a Christmas-card view in the aftermath of a snowstorm. The limestone knobs at the left of the view that gave Knowlton (Knoll-town) its name provided a natural barrier to the east, and the Delaware River is to the west.

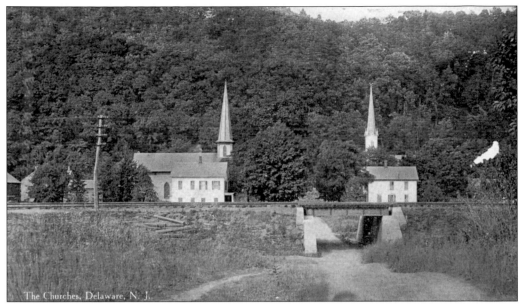

The Churches, Delaware, N. J.

Two of Delaware's churches are located on Clarence Street. St. James Episcopal Church (left) was built in 1869 after a fire, reportedly started by sparks from a Lackawanna locomotive, destroyed an earlier structure located one-half mile south. The Delaware Presbyterian Church (right) was organized on June 7, 1871, as a mission of the Knowlton Presbyterian Church, and the building was constructed in 1875. Blair presided at the dedication ceremonies and presented the land and the parsonage as a gift.

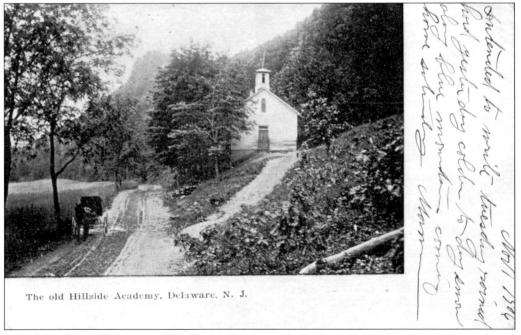

The old Hillside Academy, Delaware, N. J.

The old Delaware School, or Hillside Academy, was built above Valley Street on land purchased from Blair. It replaced an earlier overcrowded building constructed in 1784 on land donated by Robert Allison. After being replaced by a new frame school fronting on Ferry Lane, the building was dismantled and reconstructed on the dairy farm of Lawrence Makarevich.

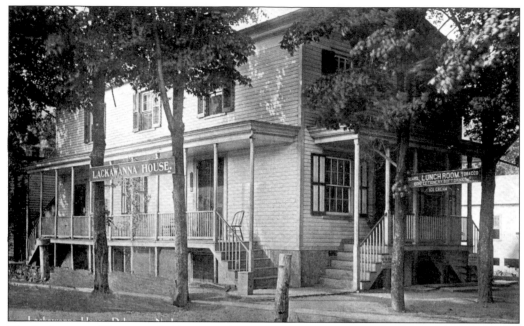

The Lackawanna House was built in 1860 by George G. Flummerfelt and contained the restaurant of Charles Cool. Flummerfelt rented rooms upstairs to boarders. According to the sign at right, the lunchroom offered cigars, tobacco, confectionery, soft drinks, and ice cream. By the 1930s, the hotel was operated by C. B. Treible.

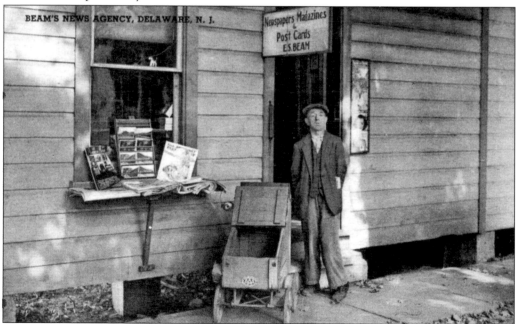

Elmer S. Beam operated the local news agency in a small room at Hutchinson's Feed Store on Clinton Street. Beam was a disabled man who drew the sympathy of some townsfolk who helped him establish his business. Here he poses with some of his wares, including newspapers, magazines (the *Saturday Evening Post* is visible), and postcards. The small wagon was built for him to transport his stock to the train station to meet incoming passengers.

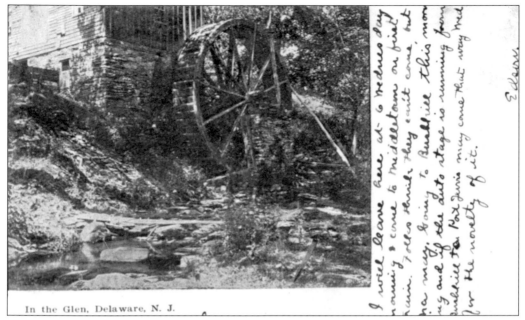

In the Glen, Delaware, N. J.

This mill, located in the Glen of Delawanna Creek just above the Delawanna House, was built by Charles Cool and was first used as a distillery. It later became a slate factory, producing school slates, slate pencils, and slate washboards. On the back, sender Edson writes in 1907, "Going to Bushkill this morning and if the auto stage is running from Bushkill to Port Jervis may come that way Wed. for the novelty of it." It is interesting to think of the motorized bus as a novelty.

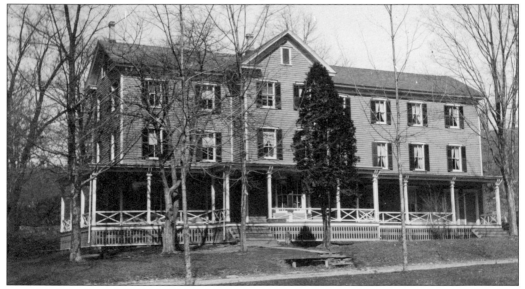

The Delawanna House, located above the village on Delaware Street, was Delaware's premier hotel. It evolved as a sideline to William F. Hutchinson's 1850 milling business. When Hutchinson retired in 1871 at age 50, his younger brother, James, took over operation of the mill. James's wife, Mary, opened the first boardinghouse in the residence next door, and it proved so successful that it was expanded several times. At the peak of operations, the Delawanna House, named after the creek that was diverted through an iron pipe to power the mill, could accommodate 50 guests at rates from $6 to $10 per week and was open seasonally from May 1 to November 1.

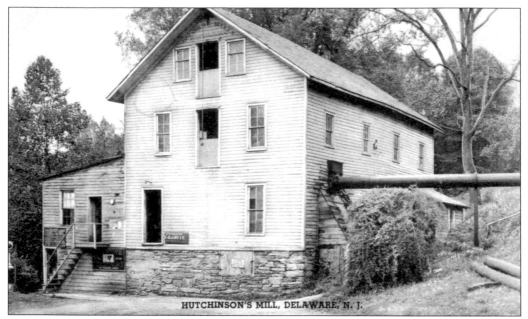

HUTCHINSON'S MILL, DELAWARE, N. J.

Hutchinson's Mill sat just below the Delawanna House. The pipe that diverted Delawanna Creek into the building to turn the giant grinding wheel is visible to the right. The milling operations reached their peak in the late 1800s, but by 1938, the business was dead, killed by cheaper flour from the Midwest. The frame portion of the mill was eventually torn down in 1950, leaving only the stone foundation that survives today.

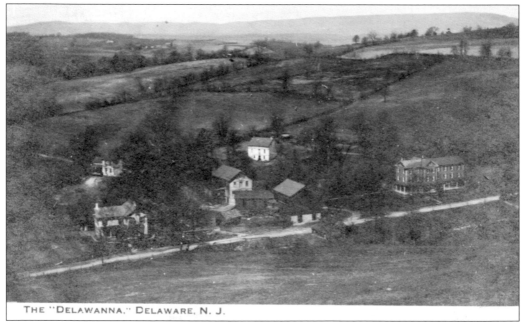

THE "DELAWANNA." DELAWARE, N. J.

A panorama of the complex shows the Delawanna House at the right and Hutchinson's Mill at the center behind the wooden barn. The white stone house above the mill was built in 1740 by Cornelius Albertson, who was also the first miller in the area. His house was a local fort during the French and Indian War. The Albertson family sold the property to the Hutchinsons in 1850.

Other small hotels and boardinghouses served the area around Delaware, New Jersey. The Spring Brook Place lay one mile south at Ramsayburg, a small village now lost to time. A hotel existed on the spot as early as 1852 and evolved into this building by the 1930s. The Spring Brook Farm Hotel opened in 1901 and was operated into the 1970s. It was destroyed by fire in 1997. J. E. Kimenour was the manager in 1903, accommodating 25 people at rates of $8 to $10 per week.

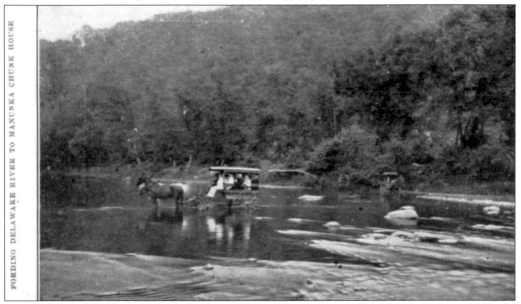

Manunka Chunk House sat on an island in the Delaware River just below Ramsayburg (or Ramseyburg), but sported a Pennsylvania address. When the river was low, a horse and coach could ford the river. Mrs. M. L. Brisbane, the owner and manager in 1915, advised patrons to take the Lackawanna Railroad to Delaware where they would be met by conveyance. The Manunka Chunk House advertised an "excellent table, fine bathing, fishing, boating, pool, etc.," and could accommodate 50 guests at rates of $10 and up per week.

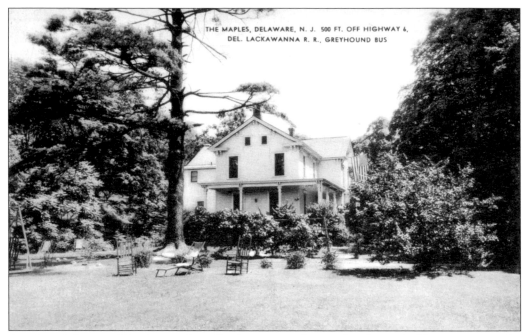

Another Delaware, New Jersey, boardinghouse was the Maples, located off Route 46 on the Knowlton-Delaware Road. The card dates to the 1940s and, as a sign of the times, the Maples touted itself as being accessible by Greyhound bus. By this time, the railroad line through Delaware had been downgraded to secondary status, and trains were few and far between.

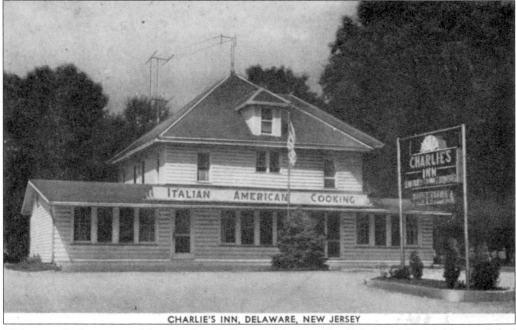

Visitors to Delaware could enjoy fine Italian cooking at Charlie's Inn. The highly modified building still sits across Ferry Lane from the Delaware School. Charlie's Inn was typical of the many roadhouses that sprang up along old Route 6 (now Route 46) between Columbia and Hackettstown, New Jersey, as roads improved and automobile travel became popular.

Although showing a Delaware, New Jersey, address, the Riverside House was physically located in Mount Bethel, Pennsylvania, on the banks of the Delaware River. A 1903 advertisement read, "It is reached by carriage after a short drive from Delaware Station to the river, and thence over the romantic ferry to the shores of Pennsylvania." The Riverside House accommodated 20 guests at rates of $7 per week in 1903.

The romantic ferry referenced in the advertisement was Myer's Ferry, which departed from the foot of Ferry Lane below the new Delaware School. The Myer name stuck even though the operation was taken over by Charles Hartzell around 1900. In this early view, the entrance appears somewhat overgrown, and it may well be that this photograph was taken after 1914 when the ferry service was abandoned.

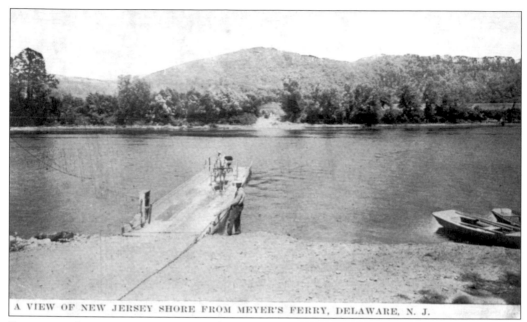

A VIEW OF NEW JERSEY SHORE FROM MEYER'S FERRY, DELAWARE, N. J.

Ferry operations were an interesting affair, as seen in this early view of Myer's Ferry from the Pennsylvania shore. The ferry was essentially a flatboat, attached to a cross-river cable at the front and rear. By adjusting the tethers to keep the keel of the boat riding with the current, waterpower literally pushed the boat along the cable. On a normal day, a crossing might take five minutes, but with a swift current and high water, it might be achieved in one.

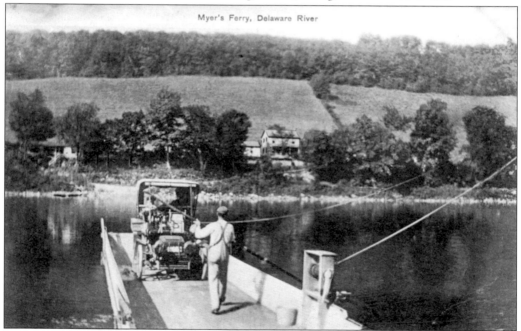

A close-up of Myer's Ferry clearly shows the two lines that tethered the boat to the cross-river cable. One of the two winches used to shorten or lengthen the tether is visible in the foreground. The boat, made of white pine, was 55 feet long and 18 feet wide and could accommodate three automobiles or two teams and wagons as well as freight and passengers.

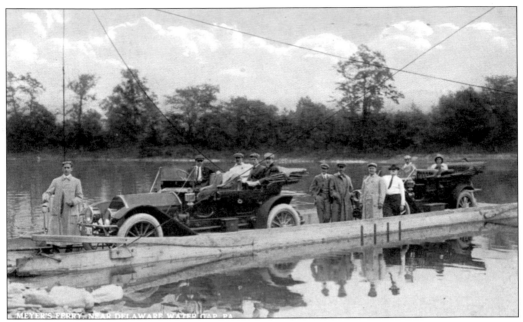

Two touring cars sit on the deck in this view of Myer's Ferry about 1910. Dusters, gloves, and hats were the garb of the day for these early automobilers who had to contend with the dirt and dust of the country roads. The ferryman used an 18-foot spruce pole to help guide the ferry across the river and for pushing off and landing.

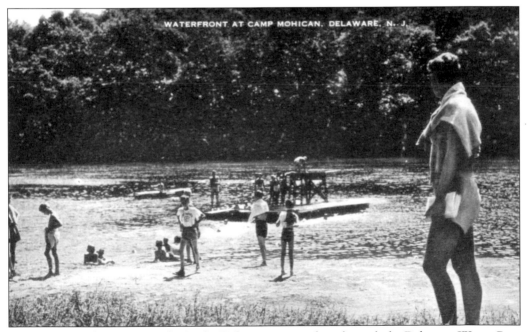

Camping was also quite popular in the Delaware area and up through the Delaware Water Gap, as churches and Boy Scout organizations snapped up cheap land during the early part of the 20th century. Camp Mohican was located on the river at the location of today's Delaware River Family Campground just south of Ferry Lane.

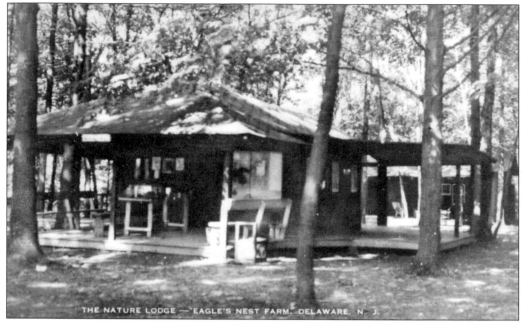

THE NATURE LODGE — EAGLE'S NEST FARM, DELAWARE, N. J.

Eagle's Nest Farm and Holiday House were built on properties donated to the Episcopal Diocese of Newark, New Jersey, by Sarah E. Albertson and Ellen M. Cummins. Eagle's Nest Farm was located on the Delaware River just south of the railroad and highway bridges and was opened in 1922. Here is a view of the outside of the Nature Lodge. Campers could avail themselves of a lot of activities, many of them designed to be educational.

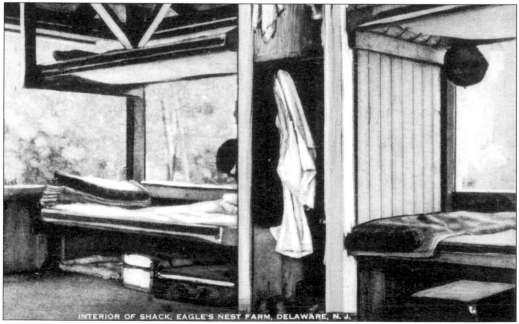

INTERIOR OF SHACK, EAGLE'S NEST FARM, DELAWARE, N. J.

Another view of Eagle's Nest Farm shows the Spartan sleeping accommodations. After a full day of swimming, horseback riding, hiking, target shooting, crafts, music, and religious education, most campers were tired by the time their heads hit the pillows.

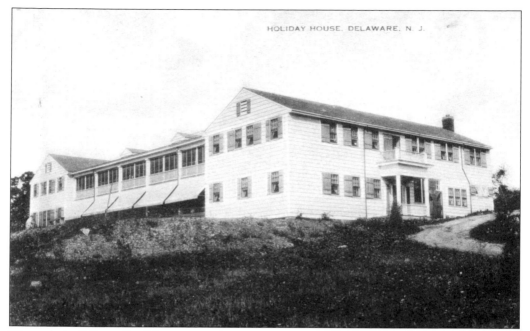

The main building of Holiday House, the Episcopal conference center at Eagle's Nest Farm, was located on a knoll overlooking the village. The diocese finally decided to sell Eagle's Nest Farm and Holiday House in the 1970s following more than 50 years of continuous operations.

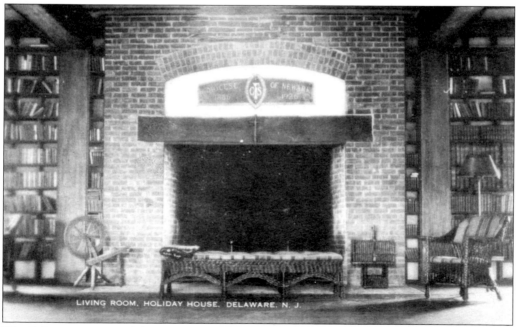

LIVING ROOM, HOLIDAY HOUSE, DELAWARE, N. J.

The living room at Holiday House shows the massive fireplace and library. Wicker furniture and an antique flax wheel complete a picture of relaxation and contemplation. The plaque over the fireplace reads, "Diocese of Newark, 1886–1926," which signifies both the year the diocese took its name and the opening of the Holiday House on October 16, 1926.

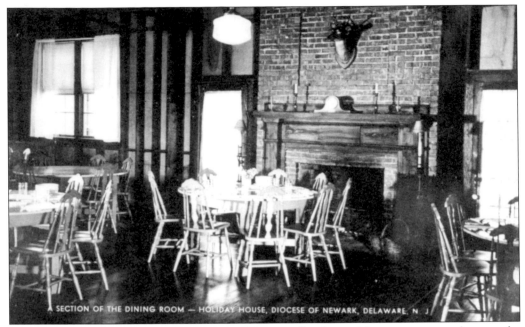

The dining room of Holiday House sported its own fireplace with an ornate wooden mantle, and a mounted deer head enhanced the rustic atmosphere. Episcopalians from the city would certainly have found Holiday House restful and serene, especially, as one participant noted, "when the children are not here."

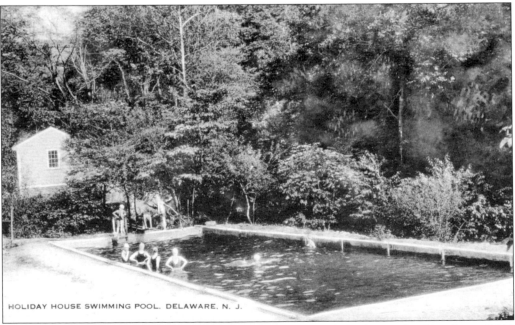

The swimming pool at Holiday House seems to be conveniently built into the side of a small hill and forested area. After the sale to a private owner, Holiday House was deemed an "attractive nuisance" and demolished, with only the chimneys left standing.

Three

COLUMBIA, DUNNFIELD,
AND PAHAQUARRY
LOST PLACES

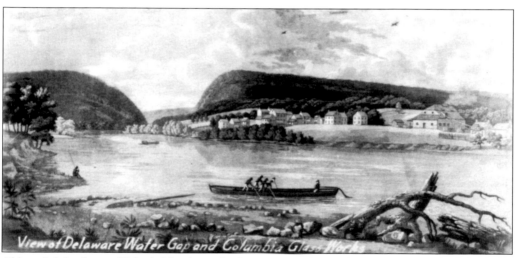

Although John Scott of Rhode Island was the first man to survey and own 15,000 acres of property in what is now Columbia, New Jersey, in Knowlton Township, it was Francis Meyerhoff, who created the village. Predating the actions of John I. Blair at Delaware, New Jersey, Meyerhoff, a German immigrant, purchased the property in 1812 for $20,000 and resurveyed the acreage, laying out over 300 lots on blocks three lots wide by eight lots long. He then sold them to various enterprises. Meyerhoff also built a glass factory, using the plentiful supplies of local flint and wood, but sand had to be brought in either from Philadelphia or from Hardwick, New Jersey. In 1825, the business failed and was disposed of at a sheriff's sale to Abram Pisch and then to William Liliendohals and finally S. Smouth, none of whom were successful. The factory closed for good in 1830. Thomas Birch's oil painting of Columbia and the Meyerhoff Glass Works is depicted in this postcard copy.

A 1910 view shows the three-story frame building at the southwest corner of Decatur and Columbia Streets built by Herman Geisse in 1813. It was reported that a cigar factory operated on the top floor. Green and Creamer ran a store on the lower level as early as 1837. The building was ultimately destroyed by fire and replaced by a smaller store.

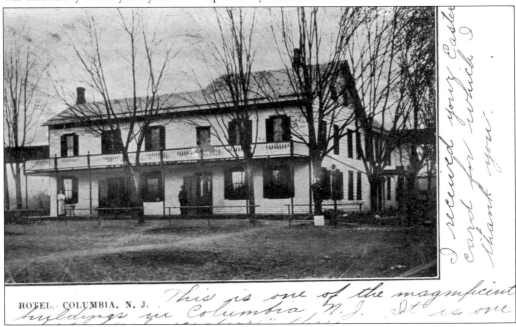

HOTEL, COLUMBIA, N. J.

The Columbia House stood at the northwest corner of Decatur and Columbia Streets. It was built in 1828 by John J. Van Kirk, who also served as sheriff from 1851 to 1854. G. H. Brugler operated the enterprise in 1903. The hotel could accommodate 25 people at rates from $6 to $9 per week and provided livery for Lackawanna Railroad passengers detraining at Portland, Pennsylvania, across the Delaware River. Passengers arriving on Susquehanna trains could walk the two blocks from the Columbia depot. The hotel was destroyed by fire on February 28, 1963.

The Methodist Episcopal Church in Columbia, New Jersey, had its origins in 1831 when Columbia and Hainesburg were accepted as part of the Hope Circuit under the pastoral leadership of the Reverends Jacob Hevenor and Caleb Lippencott. The first church building was erected in 1840 by Nelson Lake of Easton, Pennsylvania, on land purchased from William and Mary Green for the sum of $100. The original building served until 1902 when it was torn down and replaced by the structure shown here, which still stands as a private home on Church Street.

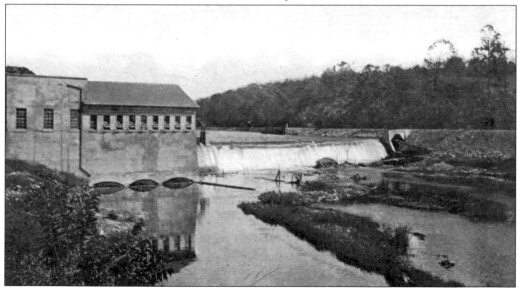

An attempt to build a power plant near the mouth of the Paulinskill River was begun in June 1901 by the Consolidated Ice and Electrical Company. Under the direction of E. P. Osgood, 50 men began erecting a coffer dam and generating station that would provide electricity both for the village and a proposed trolley line that would run to Newton, New Jersey. Heavy rains in 1901 and 1902 wreaked havoc, and the flood of 1903 finally killed the project. A second dam and generating station, shown here, were completed 200 yards upriver by the Eastern Pennsylvania Power Company in 1910. The Blairstown Railway's roadbed is visible along the far bank.

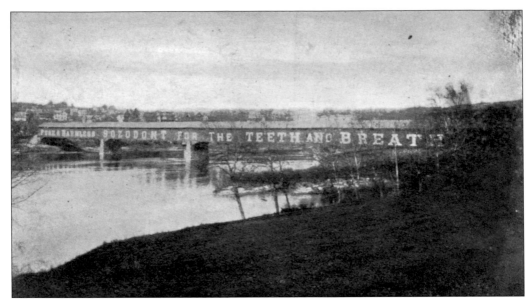

The Columbia–Portland covered bridge was completed by the Charles, Kellogg and Maurice Company (later the Union Bridge Company) in 1869. Costing $40,000, the Burr truss–type span was 775 feet long and 18 feet wide, making it the longest covered bridge in the United States. Tolls were collected at a tollhouse on the Pennsylvania side of the Delaware River until June 16, 1927, when the bridge was purchased by the Delaware River Bridge Commission and freed.

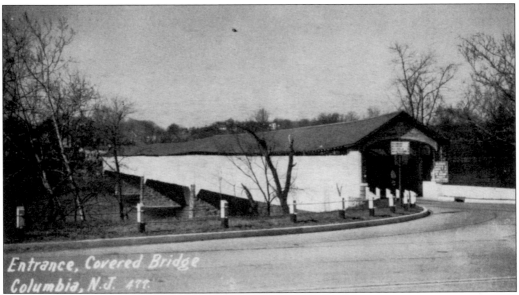

A 1940s view depicts the Columbia, New Jersey, entrance to the covered bridge at Green Street. The span carried vehicles until November 30, 1953, when it was closed to all but pedestrians. It had survived numerous floods, the most notable being in 1903 and 1936, and a tornado on April 1, 1929, which tore most of the siding and several feet off the roof of the structure, closing it for a month. But the end came on August 20, 1955, when the one-two punch of Hurricanes Connie and Diane caused a massive flood that rose above the level of the deck and carried the structure downriver.

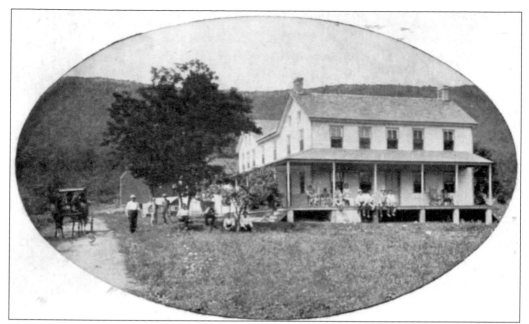

Little is remembered about the Elysian Country Club, which listed its post office address as Columbia. Two views here show the farmhouse-type clubhouse with its gigantic wraparound porch and guests relaxing in the shade. The man in the white shirt appears to be the same individual in both photographs and may be the manager. Many of the local "resorts" were simply farmhouses that opened their doors to summer visitors, much like the traditions of the bed–and–breakfast inns of today.

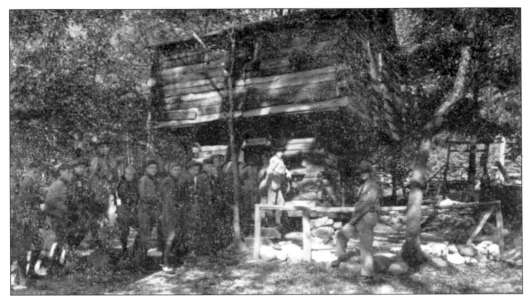

Boy Scouts bivouacked at Camp Weygadt in the Delaware Water Gap through a lease agreement beginning in 1921 and finally purchased 1,248 acres of riverfront property from the Fidelity Philadelphia Trust Fund in 1925 for $12,500. Located 2.5 miles north of Columbia, New Jersey, the camp formally opened in 1931 after the completion of the dining room, Mitchell Hall. Here Scouts pose in front of the trading post, where they could purchase equipment and supplies. In 1968, the federal government began the program of land purchase in the Delaware Water Gap for the construction of the Tocks Island Dam project, and the Delaware River camps were closed.

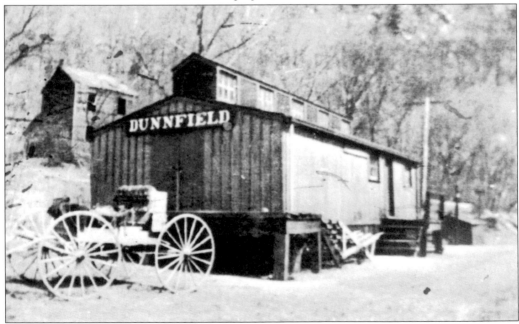

Howey's and Dunnfield, located 3.5 miles north of Columbia, were essentially slate quarrying communities, which shared school and post office facilities. Children from Dunnfield attended the Howey's school, and the Howey's residents picked up their mail and caught their trains at this odd-looking Susquehanna depot at Dunnfield.

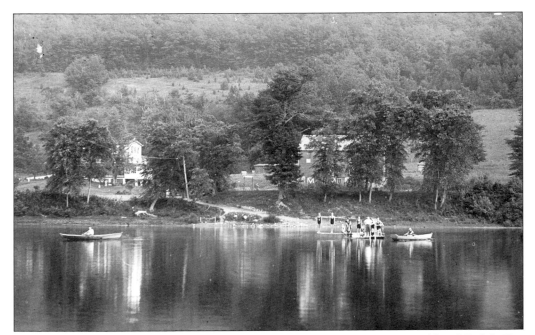

The Mountain Side House near Dunnfield was operated by George F. Boxold and Ralph Van Hagen. The farm was open year-round and could accommodate 30 people. It occupied 80 acres, fronting on one-half mile of river. It advertised "fresh vegetables, milk and eggs from our farm. Home cooked food exclusively. Wonderful spring water."

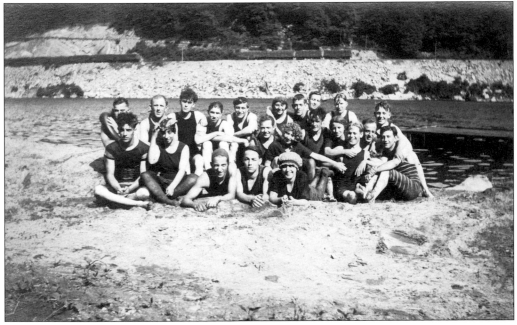

Dunnfield was originally known as Delaware Water Gap, New Jersey. It was located along the east bank of the Delaware River where Dunnfield Creek empties into the river near the beach at Kittatinny Point by today's National Park Service visitors' center. In a long-ago summer, a group of young men and women pose for the photographer along the sandy shore. The Lackawanna Railroad is visible in the background on the Pennsylvania side.

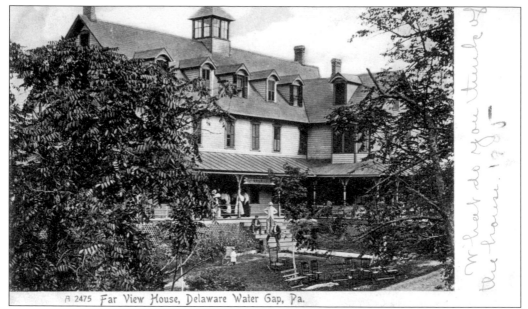

Although sporting a Delaware Water Gap, Pennsylvania, mailing address, the Far View House actually was located on Blockade Mountain in New Jersey, overlooking the Susquehanna's bridge into Pennsylvania. In 1903, Adam Transue was the owner. The Far View House accommodated 90 guests at $6 to $10 per week and advertised extensive views, fine roads for "wheeling" (bicycling), numerous outdoor sports, and "perfect sanitary conditions."

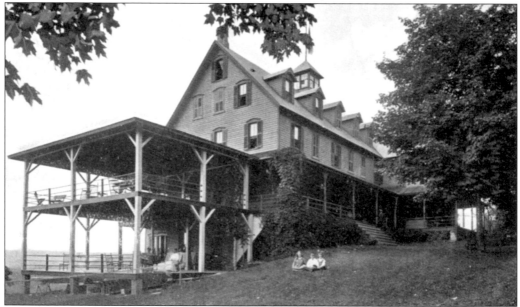

By 1915, the Far View House became the Karamac Inn and advertised itself as a "Christian resort" for "younger people and those with young minds." Through expanded facilities, it accommodated 125 guests from May 1 to November 1. Increased rates were $10 to $17.50 per week but "special inducements" were offered during June and September. It advertised verandas that were 32 feet wide, "affording open air dancing space," and "vast, densely shaded water frontage, 200 acres of lawn, baseball, tennis, tether-ball, lawn hockey, etc."

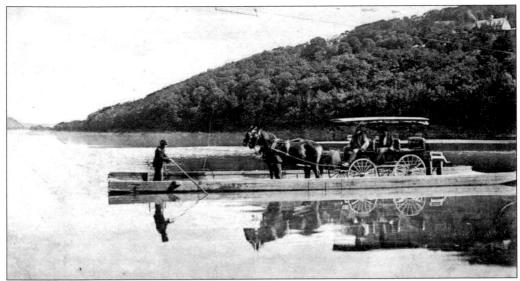

Livery to the Karamac Inn was provided by ferry from Delaware Water Gap, Pennsylvania. The first ferry here was operated by James Gould in 1736. Later records show it as either Brotzman's or Walker's Ferry, depending upon who operated it at the time. Charles C. Worthington, magnate of the Worthington Pump Corporation, purchased the ferry in 1903 and used it privately to access his estate on the thousands of acres of land he had acquired in the Delaware River valley. Worthington later sold the ferry to the Karamac Inn (visible at the upper right) to provide transportation for its guests.

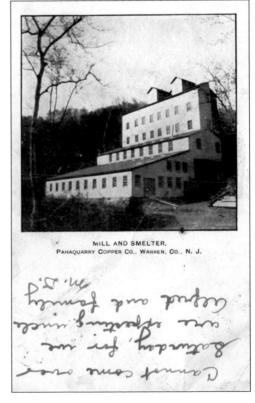

MILL AND SMELTER,
PAHAQUARRY COPPER CO., WARREN, CO., N. J.

Exploratory copper mining at Pahaquarry, New Jersey, may have begun as early as 1626 when Dutch settlers began searching for minerals in the area. But the first actual mining operations started in the 1750s. The copper extracted was low grade, and the mines were abandoned by 1760. Subsequent efforts over the next 150 years also proved unprofitable, and the last mine closed in 1918. This view shows the mill and smelter of the Pahaquarry Copper Company in 1917.

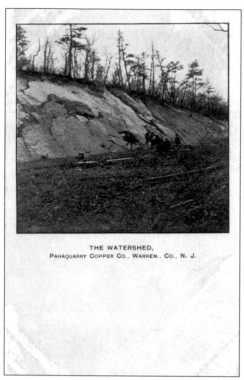

THE WATERSHED,
PAHAQUARRY COPPER CO., WARREN., CO., N. J.

The watershed at the Pahaquarry Copper Company about 1907 is seen in this vintage view. Pahaquarry, New Jersey, was the southern terminus of the Old Mine Road, or King's Highway, which ran between Esopus (Kingston), New York, and Van Campen's Inn above Pahaquarry as early as 1750. The road followed an old Native American trail and, despite the failure of the mining industry, was employed by New Jersey farmers to ship their crops north into New York.

The George Washington Council of the Boy Scouts of America purchased the grounds of the abandoned copper mines and opened the Pahaquarra Scout Reservation in the 1920s. Some surviving structures were recycled, and new buildings were constructed on other existing foundations. Like Camp Weygadt, Camp Pahaquarra became part of the Tocks Island project in 1968, and the Scouts went elsewhere. This parade ground is the site of today's Copper Mine Trail parking lot.

Four

PORTLAND
A BRIDGE NOT TOO FAR

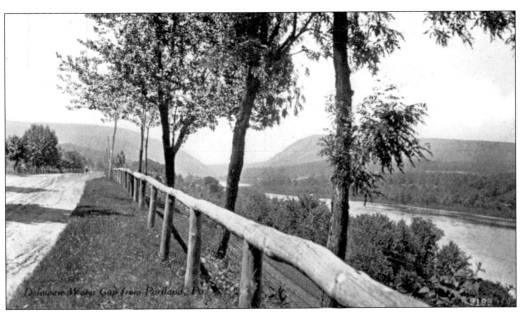

Portland, Pennsylvania, located near the northeast corner of Northampton County, was incorporated in 1876 and was formerly known as Dill's Ferry. Henry Dill did not own the ferry that bore his surname at first but operated it to Columbia, New Jersey, under a contract with the charter owner, a Mr. Smith. Dill eventually bought the ferry from Smith, legitimizing the name. He also built and operated a log tavern at the ferry location, which is said to be the first commercial enterprise in what would become Portland. History differs as to who actually christened the town, and both Capt. James Ginn of Maine and Maj. Franklin Ames of Massachusetts have received credit. This 1909 view looks north toward the Delaware Water Gap from the top of Delaware Avenue, a dirt road devoid of houses. At the lower center, the Lackawanna Railroad's old main line can be seen, winding along the Delaware River.

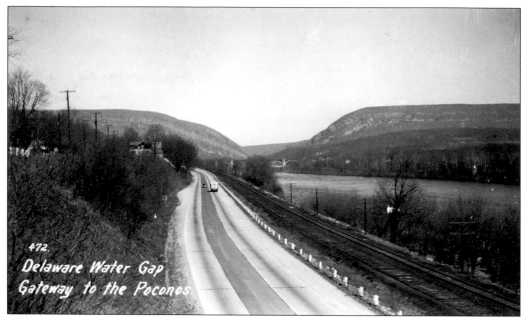

472.
*Delaware Water Gap
Gateway to the Poconos.*

Thirty years later, the Lackawanna Railroad has now been single-tracked and moved closer to the river, and a new concrete highway, Route 611, has been constructed on the former railbed. Now devoid of through traffic from Philadelphia and Easton, Pennsylvania, to the Delaware Water Gap, Delaware Avenue has resumed a sleepy existence, much as it was in the late 1800s.

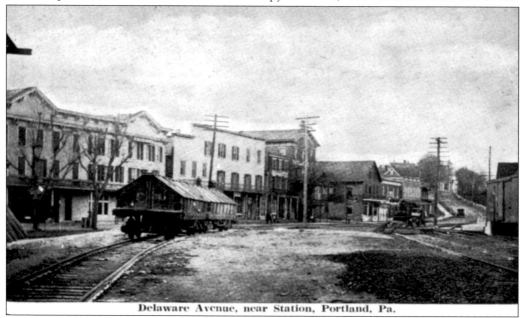

Delaware Avenue, near Station, Portland, Pa.

Downtown Portland, Pennsylvania, is seen in this view looking northwest from Williams' Coal Yard in 1912. Two coal cars occupy the siding. The Delaware House hotel is at the extreme left, competing with the Portland House, which is the tallest building at the center. Snover's Restaurant is just to the right of the Portland House. The cluster of buildings from Snover's to the bottom of the hill is less than 10 years old, as it had replaced earlier structures destroyed in the great Portland fire of April 9, 1902.

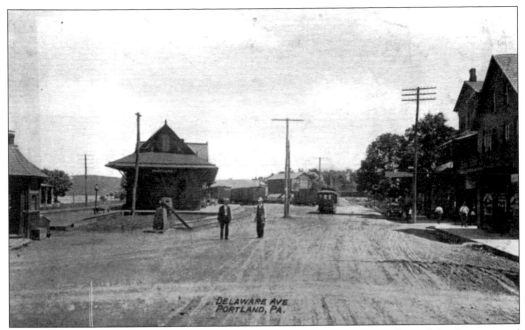

The center of Portland had a frontier look about it in 1909. The trolley of the Bangor and Portland Traction Company, having unloaded its passengers for the Lackawanna connection to the Delaware Water Gap, sits at the end of the line in front of the Lackawanna station, waiting to make its return trip to Bangor. The two men standing next to the steel bumper are probably the station agent and baggage master.

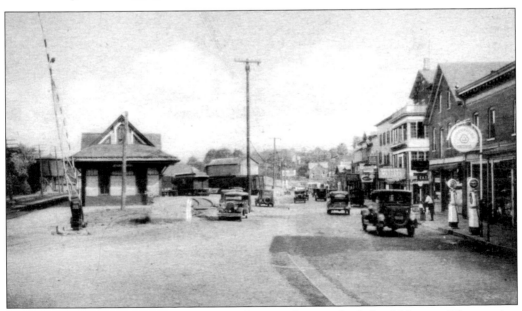

This is the same location as the view above, but time has marched ahead 30 years. The crossing watchman's shack is gone, and new gates have been erected. A water tower has mysteriously appeared alongside the tracks, the old bumper is now made of concrete, automobiles proliferate but the trolley is gone, and the Portland House has enclosed its open porches. The gas pumps at the right mark the location of James Weidman Jr.'s Ford dealership.

Portland, Pa. (Settled in Wm. Penn's Time)

This view looks toward the business district from the old quarry on Route 611 about 1940. The tall building at left is the Portland National Bank, and the old Portland Diner can be seen to the right just beyond the concrete bridge. Taft Williams's massive coal tower in the Lackawanna freight yard to the right of center almost obscures the beauty of the Delaware Water Gap, and the Lehigh and New England Railroad bridge can be seen crossing over the town in the background.

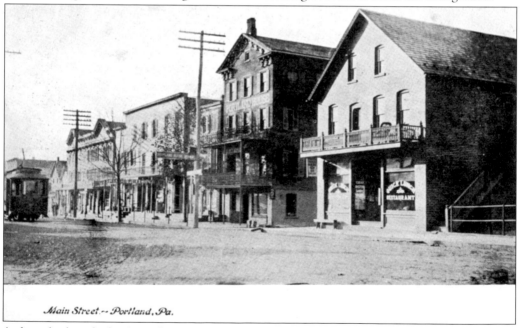

Main Street -- Portland, Pa.

A closer look at the business district reveals that the building to the right of Snover's Restaurant has not yet been rebuilt after the great fire of 1902. The Bangor and Portland Traction Company's car, seen waiting at left, first arrived in 1905, so this view probably dates to about 1906.

56

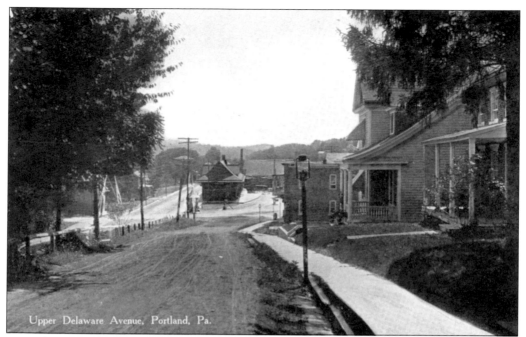

Upper Delaware Avenue, Portland, Pa.

From the top of Delaware Avenue, the Lackawanna depot is visible. Travelers from Philadelphia and Easton, Pennsylvania, arriving via the Bangor and Portland Traction Company car could take a Lackawanna train to the Delaware Water Gap or hike up this hill to catch a Stroudsburg, Water Gap and Portland Railway trolley for Slateford, Pennsylvania, and points north.

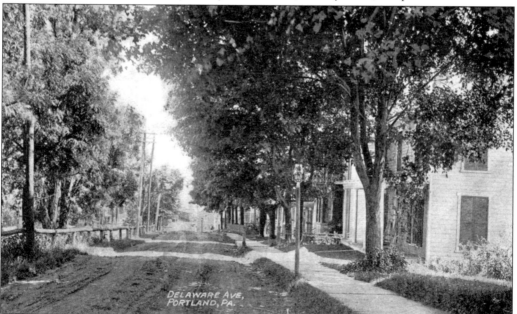

DELAWARE AVE,
PORTLAND, PA.

Over the crest, Delaware Avenue levels off and reveals its residential nature. The wooden sidewalks and kerosene streetlamps paint a picture of Victorian times, and it is hard to imagine that at this time Delaware Avenue is the main artery between Philadelphia and the Delaware Water Gap. The rustic wooden guardrail at the left protects errant carriages and pedestrians from tumbling down the hill to the railroad tracks.

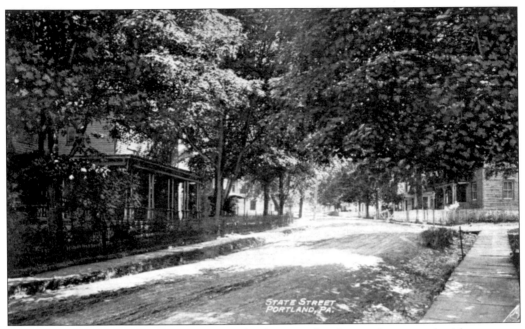

State Street, like most of the streets in Portland, Pennsylvania, was later paved with concrete. The photographer is standing in front of the old firehouse looking west up the hill toward the bridge over Jacoby Creek.

This view is looking down from the bridge over Jacoby Creek at the top of State Street in 1911. It must have been a wonderful place for coasting when the snows of winter relegated buggies, wagons, and primitive automobiles to the garage, and horse-drawn sleighs ruled the roads.

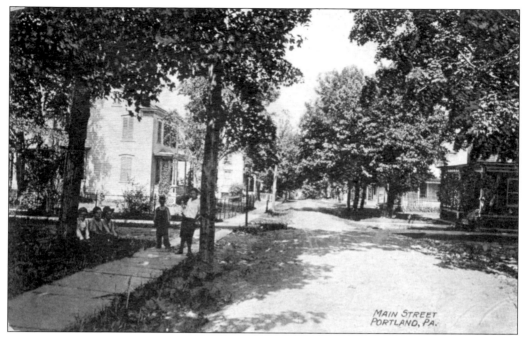

A block north is Main Street, the primary artery between the Lackawanna Railroad station on Delaware Avenue and the diminutive Lehigh and New England Railroad depot at the top of the hill. This view is from just above the intersection with Pennsylvania Avenue looking east toward the Delaware River.

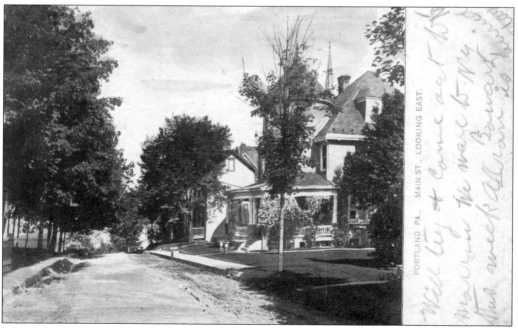

Victorian homes line both sides of Main Street in 1906. The wooden sidewalks came into existence as a result of a municipal ordinance in 1880, which required that they "be placed throughout the inhabited sections" of town. Anyone damaging the sidewalks was expected to make repairs in a timely fashion.

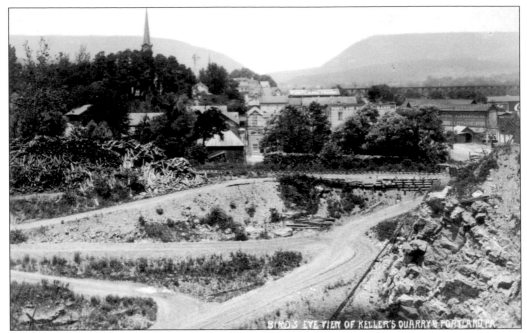

Commercial lime quarrying began in Portland, Pennsylvania, as early as 1830 when the Winten Quarry opened at the south end of the borough. The quarry was later referred to as the Keller Quarry, since it was located on the estate of Luther Keller. In this bird's-eye view of Portland from the face of Keller's Quarry, the Delaware Water Gap is clearly visible as a wonderful backdrop.

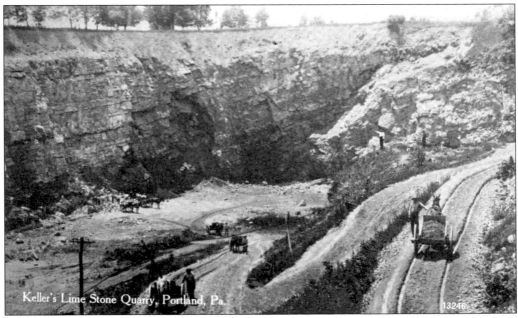

Keller's Quarry reached a maximum extent of 300 feet by 500 feet and had a working face that was 85 feet high. Keller shipped most of his lime to Scranton over the Lackawanna Railroad. Quarrying operations ceased around 1922.

The cornerstone for this brick Portland schoolhouse was laid in 1886, and the building opened for the 1887–1888 term. Florence Flint, John Niles, and Lilly Shoemaker were the teachers. The first graduation was held in 1889. By 1927, the curriculum had expanded to include a full four-year high school, but the secondary school was eliminated in 1947. The school closed permanently on June 13, 1969, and the structure became the Portland municipal building.

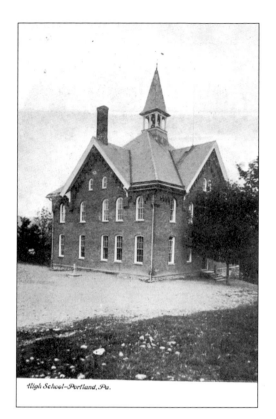

High School–Portland, Pa.

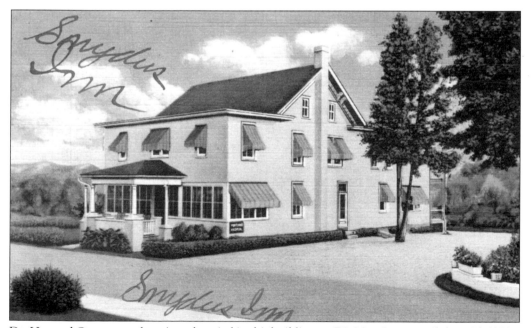

Dr. Howard Ott operated a private hospital in this building on Division Street until the mid-1930s. When the hospital closed, it briefly became a nightclub before reopening as Snyder's Inn in 1937. The inn closed before World War II, and the structure later became the Barto Nursing Home. It survives today as a private residence.

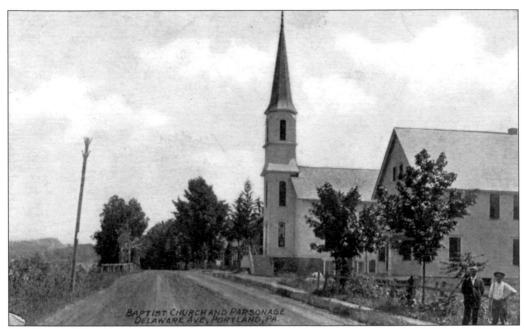

The first Baptist circuit preacher arrived in Portland, Pennsylvania, around 1834, but it was not until 1875 that the denomination granted letters to form a Baptist Church in the borough. The church building at the corner of Delaware Avenue and First Street was constructed in 1877 at a cost of $3,358.75 and dedicated on New Year's Day in 1878.

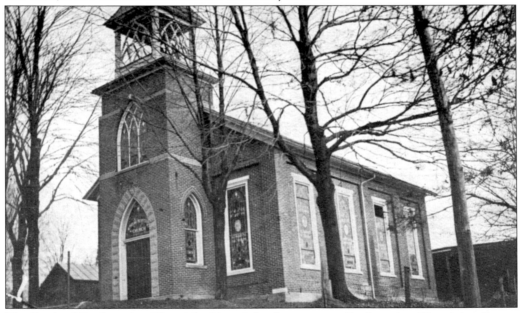

The Portland Presbyterian Church had its origins from a parent Presbyterian Church in adjacent Mount Bethel Township. The cornerstone for this brick structure on Pennsylvania Avenue was laid in 1868, and the church was granted a dismissal from Mount Bethel in 1880. The churches merged back together in 1963 at the Portland structure, and the story came full circle in 2006 when a new church was constructed back in Mount Bethel, and the aging Portland building was closed.

The first Methodist Worship Society in Portland was formed in 1866 by Brother William T. Magee. Until the present church was constructed in 1872 on property between Main and Division Streets, services were held in a two-room schoolhouse at the rear, which later became the parsonage. In 1939, the name was changed to the Portland Methodist Church.

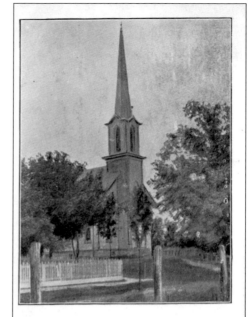

Methodist Episcopal Church. Portland, Pa.

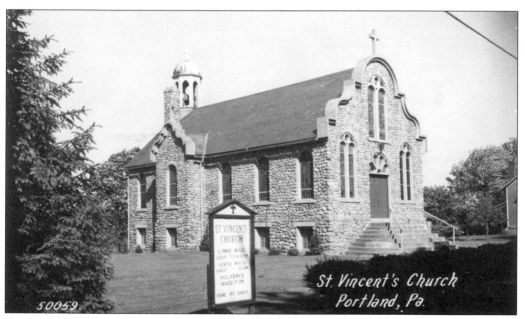

St. Vincent's Church
Portland, Pa.

Portland Catholics had to travel to attend mass in either Bangor or Roseto, Pennsylvania, until 1921, when a census determined that there were enough families to warrant a mission church. St. Vincent DePaul was built by general contractor Harry Sweeney in 1925 from native fieldstone on property donated by Charles Munsch. The building was dedicated on August 29, 1925.

63

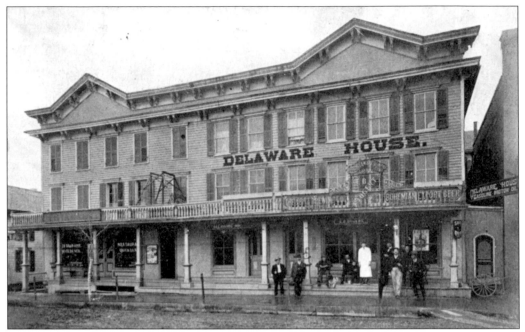

William Jones was the proprietor of the Delaware House on Delaware Avenue in 1903. The hotel could accommodate 35 guests at a rate of $6 to $9 per week. It advertised itself as a "comfortable boarding house . . . close to the shores of the Delaware River . . . and 30 yards from the [railroad] station." The building burned in a spectacular fire in July 1986.

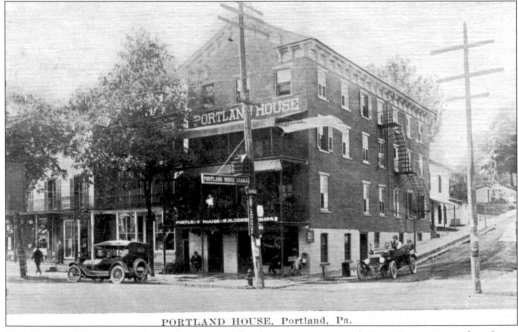

PORTLAND HOUSE, Portland, Pa.

The Portland House stands on the corner of Delaware Avenue and Main Street, just a few doors north of the Delaware House. Open all year, the hotel was managed by J. L. Johnson in 1903 and charged its 40 guests from $7 to $10 per week. In 1915, the operation was managed by Winifred J. Reed.

Jacoby Creek tumbles down from Mount Bethel into the Delaware River at Portland as a rather innocuous stream during the dry season. During severe storms and hurricanes, however, it can become a raging torrent that backs up into the lower portion of town and causes major flooding. Here in a more pastoral mood, the creek trickles over Williams's (now Hummell's) Dam at the top of State Street.

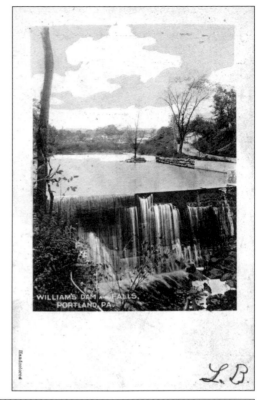

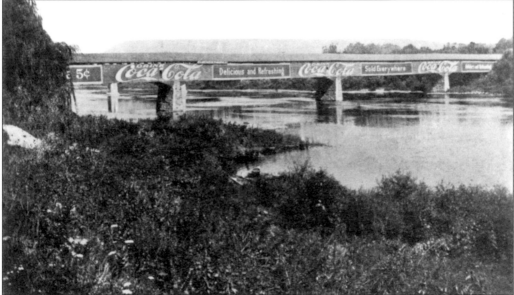

Under private ownership, advertising space was sold on the sides of the Portland–Columbia covered bridge. The venerable structure bore its most recognizable logo in 1917 when residents were encouraged to "Drink Coca-Cola, Delicious and Refreshing." It had earlier worn an advertisement for "Sozodent, For the Teeth and Breath." A red liquid dentifrice, Sozodent was 37 percent alcohol and must have always generated a smile until it was literally squeezed out of existence by the invention of the metal toothpaste tube.

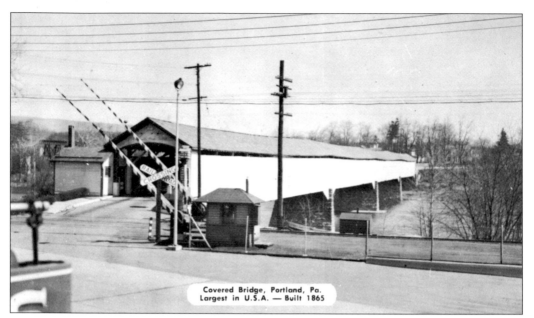

Covered Bridge, Portland, Pa.
Largest in U.S.A. — Built 1865

Longtime Portland, Pennsylvania, residents best remember the bridge in this familiar coat of whitewash that lasted until its demise at the hands of Hurricane Diane on August 20, 1955. Teams and, later, automobiles exiting the bridge on the Pennsylvania side had to contend with the tollbooth and the crossing of the Lackawanna Railroad's main line. After 1911, train traffic severely declined with the construction of the New Jersey Cut-Off that bypassed Portland, and the freeing of the bridge on June 15, 1927, eliminated any need to stop for the toll collector.

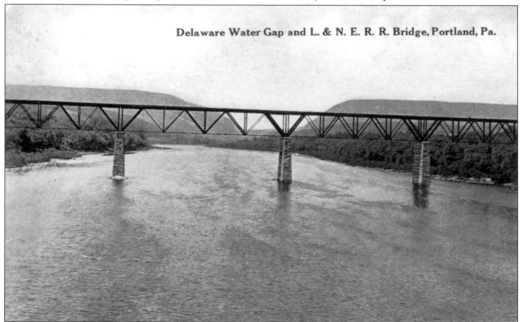

Delaware Water Gap and L. & N. E. R. R. Bridge, Portland, Pa.

The Lehigh and New England Railroad crossed the Delaware River just north of the covered bridge on this structure, which spanned not only the river but also the Lackawanna Railroad. On the New Jersey side, approaches to this bridge carried the railroad completely over the town of Columbia, and that small hamlet never had a station on the Lehigh and New England Railroad.

66

Five

SLATEFORD
A QUARRY VILLAGE
SUSPENDED IN TIME

Greetings from
Slateford, Pa.

Slateford, Pennsylvania, located between Portland borough and the Delaware Water Gap, was the property of the Pennsylvania Slate Company, which was incorporated in 1808 by James M. Porter. It initially consisted of a half-dozen homes for the workmen in addition to the various buildings associated with the quarrying and processing of roofing slate. When the Lackawanna Railroad arrived, Slateford boasted 26 residences, a hotel, a store, a schoolhouse, a blacksmith shop, and a depot. Ultimately, 12 different quarries were worked in the Slateford area with the last one being the Penrhyn or Snowden Quarry, which closed in 1917.

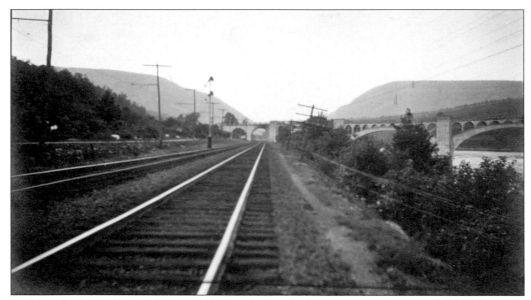

In the early days of the Lackawanna Railroad, Slateford, Pennsylvania, was probably a flag stop, but substantial depots at Portland and Delaware Water Gap, Pennsylvania, brought the station there to an early demise. This view looks north on the old main line just above the Portland border and south of the new Delaware River viaduct that carried the railroad above the borough proper. The tracks of the Stroudsburg, Water Gap and Portland Railway ran along Main Street at the left.

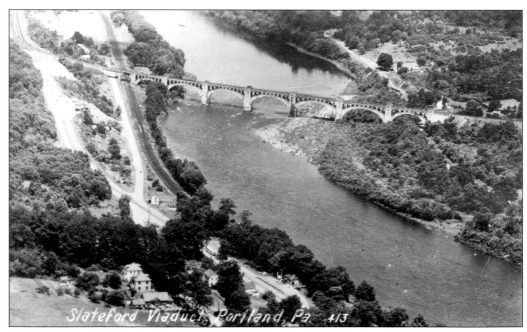

An aerial view of Slateford about 1945 shows both Lackawanna lines and the Delaware River viaduct. Route 611 has been improved and intersects the concrete Lackawanna Trail (Main Street) at the lower left corner of the photograph.

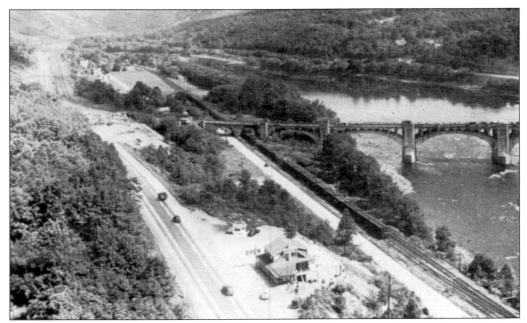

Although the card is identified as Portland, the scene is actually at the southern border of Slateford and shows Otto Hochrein's Grand View Inn perched above the river. Hochrein purchased the business in 1945 from Leonard Rinaldi who established it as a combination hot dog stand and gas station in 1936.

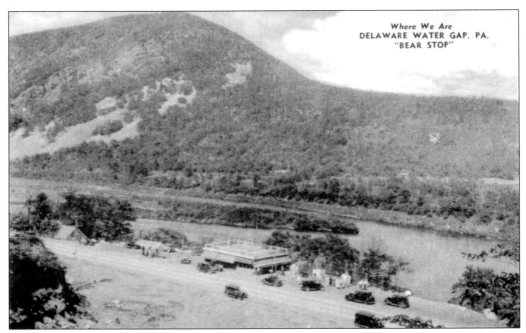

One of the best-known attractions in the Slateford area was the Bear Stop. There actually were three Bear Stops. The third and most familiar Bear Stop was built on the current location of the National Park Service's Arrow Island Overlook by Al Cox and is the one best remembered by tourists who stopped there for gas and food, taking time to also check out the caged bear next door and the deer pens and pony rides on the opposite side of Route 611.

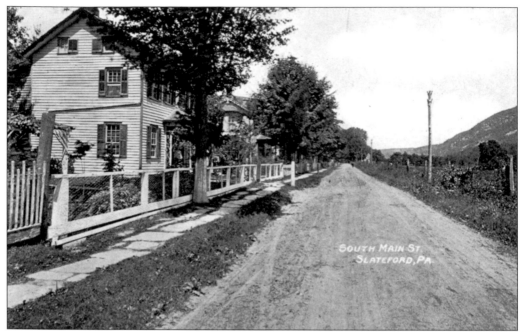

This bucolic view looks north on Main Street toward the Delaware Water Gap about 1908. Three years later, cars of the Stroudsburg, Water Gap and Portland Railway trolley will run down the shoulder of this road, bringing tourists to the area.

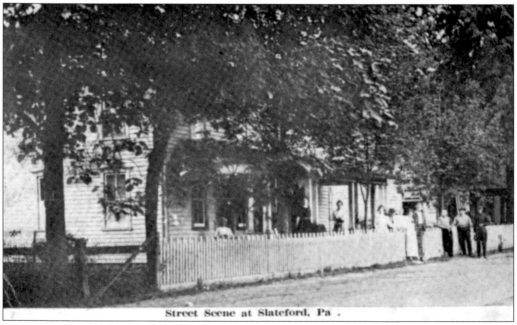

Street Scene at Slateford, Pa .

A number of the locals have come out to pose for the photographer in this street scene at Slateford, Pennsylvania, in 1908. Slate quarrying was hard and demanding work, which paid low wages and was dependent to some degree on the weather. The quarrying and block making took place outside and stopped when the weather was bad.

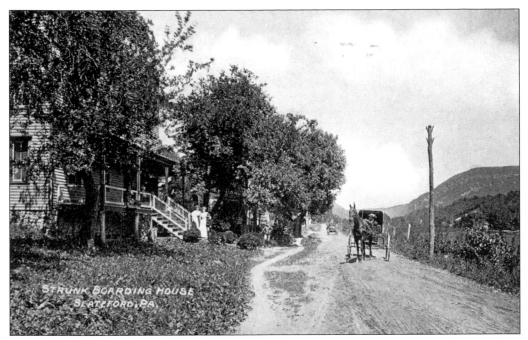

Rosa Paul Strunk operated the Riverside Cottage in Slateford and accommodated 20 people in 1903 at rates of $6 to $10 per week. By 1915, she became Rosa Williams and advertised bed and board for 25 guests at rates that had barely increased to $8 to $10 per week. Williams touted the large verandas and a more utilitarian "bath and toilet," as well as trolley service to the Delaware Water Gap, which stopped right in front of the building after 1911.

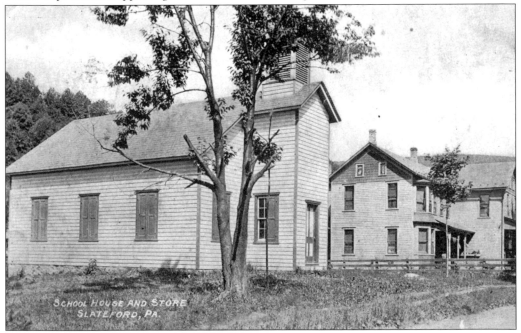

The one-room schoolhouse at Slateford was built before 1860 and sold in 1899, when it was replaced by a new building across Main Street. The structure to the right of the school is Sigafuss's General Store.

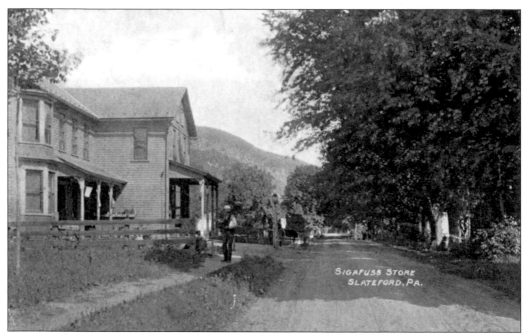

Philip Sigafuss built this store about 1902 and was known for carrying a complete line of wares from food and textiles to clothing, shoes, hardware, and even postcards. The post office alternated between here and the competing Williams' Store, depending upon which of the two belonged to the political party currently in power.

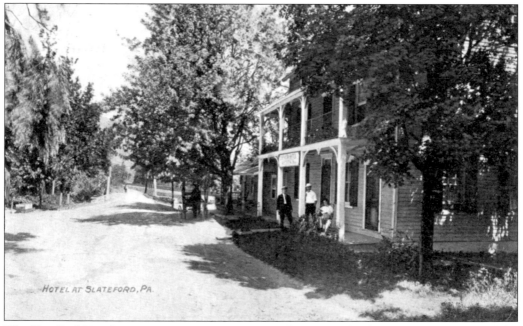

The Slateford Hotel can trace its origins to 1817 when it was built to serve the needs of the loggers working in the Delaware Water Gap area. Oliver Titus was the proprietor in 1910 when this photograph was taken. George Decker operated a ferry to New Jersey starting in 1856 from a point just south of the hotel.

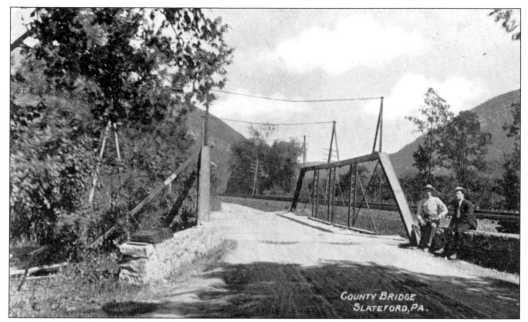

Just north of the Slateford Hotel, Main Street crossed Slateford Creek on this iron bridge, which was constructed by Northampton County. The Delaware Water Gap and Lackawanna Railroad tracks of the old main line can be seen in the background. The two men sitting on the stone wall are identified as Philip Sigafuss (left) and William Mills.

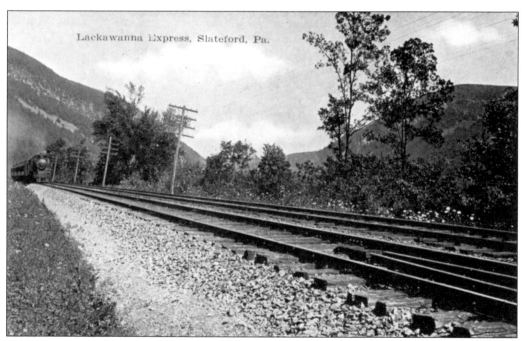

A Lackawanna Railroad express train rolls east into Slateford in this view taken about 1910. The train is on its way to Hoboken via Washington, New Jersey, on what was to shortly become known as the old road. As this photograph was snapped, construction was proceeding on the New Jersey Cut-Off that would downgrade this line to secondary status.

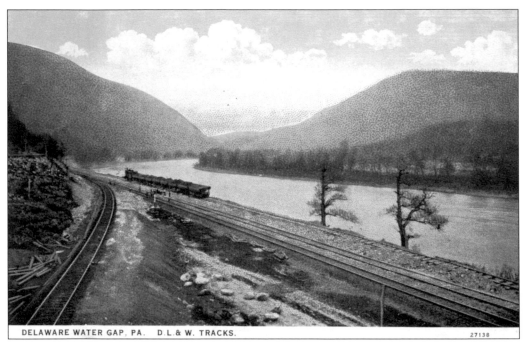

DELAWARE WATER GAP, PA. D.L.& W. TRACKS. 27138

These two postcard views depict the evolution of Slateford Junction. In the above view, the junction is still under construction in 1911. The old main line south to Portland, Pennsylvania, and Delaware Station, New Jersey, runs toward the lower right, and the new track of the New Jersey Cut-Off is visible at left. A ballast train is dumping rock at left of center. In the view below, the junction has been completed, and a Lackawanna passenger train is rolling east past Slateford Tower onto the old main line, a much rarer occurrence now, since most express trains operated over the cutoff after its official opening on December 24, 1911.

Delaware River below Gap,
Delaware Water Gap, Pa.

Six

DELAWARE WATER GAP
A NATURAL WONDER

It was described as nature's "Eighth Wonder of the World," and was eclipsed only by Saratoga Springs, New York, as an eastern resort destination in 1905. The first Native Americans to set eyes on the region were members of the Lenni-Lenape Nation, who found a fertile valley blessed with abundant water and teeming with game. In the early 1700s, William Penn, a devout Quaker who always believed in dealing fairly with the natives, purchased tracts of land from local tribes that were measured by walking the boundaries at a pace normal for the natives. In 1737, heirs of Penn, wishing to expand their land holdings north, made a similar deal with the Lenapes, but unknown to the Native Americans, they hired three of the fastest runners in the colony to set a terrific pace for the walk. At the end of the preagreed day-and-a-half time period, Edward Marshall, the quickest runner, had reached the area around Mauch Chunk, Pennsylvania, nearly twice the distance that the Lenapes expected. The Lenapes felt cheated, and the notorious Walking Purchase caused friction with settlers for years.

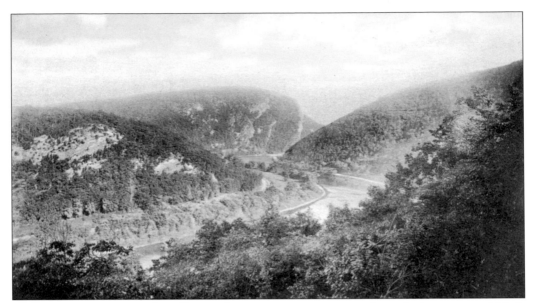

The Delaware River took millions of years to carve a passage through the range, which is respectively called the Blue Mountains in Pennsylvania and the Kittatinny Mountains in New Jersey. Three peaks overlook the waterway, and all are visible in this view looking south through the gap from the mountain road near the Kittatinny Hotel, with Mount Tammany in the distance, Mount Minsi to the right, and Blockade Mountain to the left. The flat area at the left shore is the town of Dunnfield, New Jersey.

New Hampshire had its Old Man of the Mountain, and New Jersey has its Indian Head. The Native American profile on the side of Mount Tammany is best viewed from across the river in Pennsylvania at Point of Gap. The face with flowing hair and headdress is still a tourist attraction.

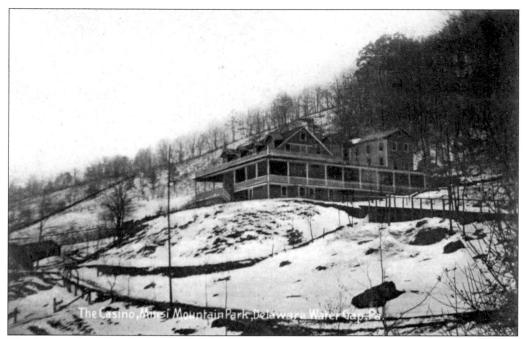

Moving north on the road from Slateford to Delaware Water Gap, Pennsylvania, visitors might stay at Minsi Mountain Park, located on the eastern face of Mount Minsi and extending nearly to Point of Gap. The Casino Hotel was one of three lodging facilities on the property, which was managed in 1915 by C. T. Nightingale. It could accommodate 60 guests at rates of $10 to $20 per week.

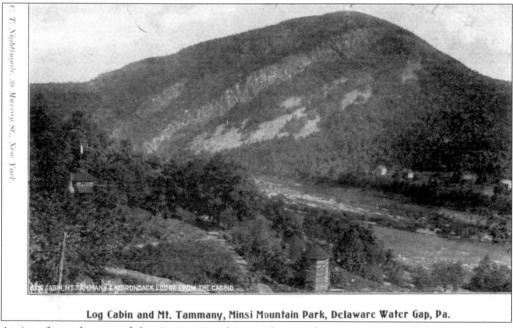

Log Cabin and Mt. Tammany, Minsi Mountain Park, Delaware Water Gap, Pa.

A view from the top of the Casino Hotel grounds provides a grand vista of the river, Arrow Island, and Mount Tammany on the New Jersey shore. The property lies within the boundaries of the Delaware Water Gap National Recreation Area today.

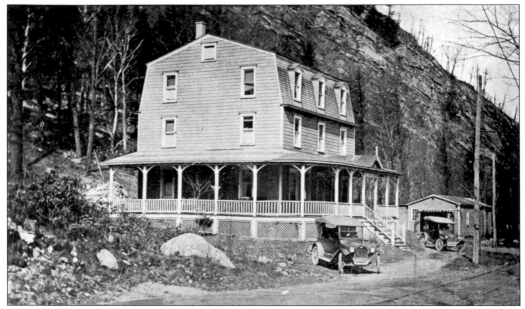

The Gap Inn (shown here) and Mount Minsi House were the other two boarding facilities at Minsi Mountain Park. In 1915, The Gap Inn accommodated 20 guests at $8 to $12 per week, and the Mount Minsi House held 40 at the same rates. The park also advertised rustic bungalows and cottage sites and promoted itself as "the Garden Spot of the Gap." It offered "billiards, pool, dancing, boating, automobiles, and horses," and touted its "own garden and truck farm." The Benner Health Spa was also located on the property.

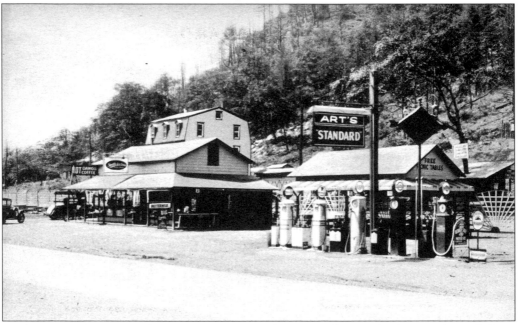

By the 1930s, the area reached its maximum development. The new highway, relocated closer to the river, passes in front of Art Bartron's stand and Standard Oil pumps, and the Gap Inn peers over the top of the building. All of this vintage Americana is gone today, replaced by the Point of Gap parking area.

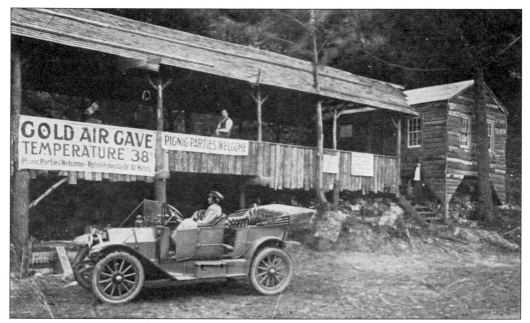

A famous attraction near the north end of Minsi Mountain Park was Cold Air Cave, operated by Myrtle "Ma" Williams. One of a number of naturally occurring caves along the Delaware River, it offered summer relief to visitors who enjoyed its constant temperature of 38 degrees. The building to the right was the original concession stand, and the pavilion was added later. The entire rustic structure was eventually replaced by a more modern souvenir shop and gas station.

The mountain road through the Delaware Water Gap was barely wide enough for one carriage, and it is hard to imagine that it was the forerunner of today's busy Route 611. On February 11, 1911, the Lackawanna Railroad dynamited the hillside to widen the road for the construction of the Stroudsburg, Water Gap and Portland Railway trolley, unknowingly providing the necessary space for the highway of today.

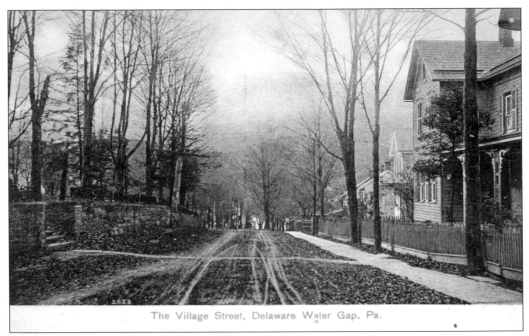

The Village Street, Delaware Water Gap, Pa.

Two views of Main Street in the village of Delaware Water Gap, Pennsylvania, in 1910 provide wonderful vignettes of Victorian living. It is easy to see why the trolley line bypassed this steep roadway in favor of the longer route via Oak Street that took the line around the northwest corner of town.

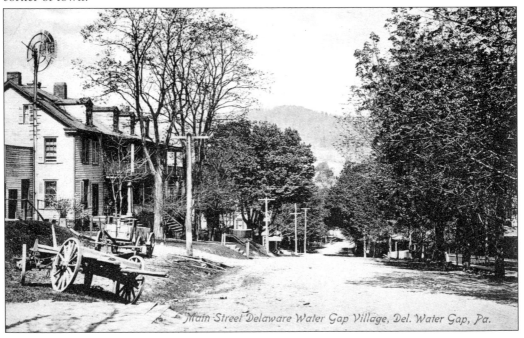

Main Street Delaware Water Gap Village, Del. Water Gap, Pa.

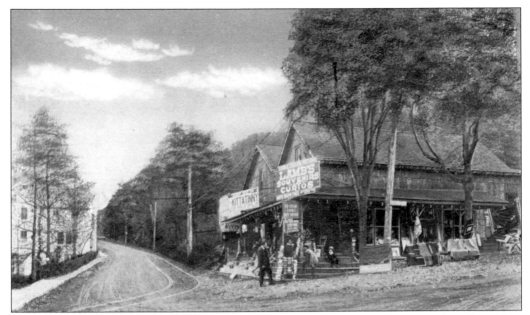

Lamb's was one of the two notable souvenir shops in town, with Hauser's being the other. They were located less than 50 yards apart near the trolley terminal by the Castle Inn and sold a variety of items to tourists, including many of the postcards in this volume. Hauser's building stands proudly today at the corner of Delaware Avenue and Waring Drive with its venerable name still displayed over the door. The foundation of Lamb's can still be seen at the intersection of Main Street and Mountain Road.

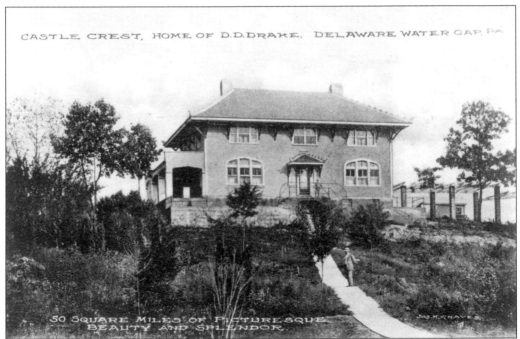

Castle Crest was the mansion of Dimmick D. Drake, owner of the Castle Inn. His family was an integral part of Delaware Water Gap for many years. The caption states, "30 Square Miles of Picturesque Beauty and Splendor," referring to the gap area rather than just the Drake estate.

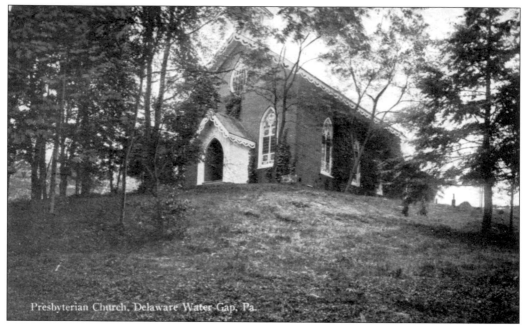

The Presbyterian Church of the Mountain was organized on January 22, 1854. The building was dedicated on August 29, 1854, with the Reverend Horatio S. Howell as the first pastor. Howell, chaplain of the 90th Regiment, Pennsylvania Volunteers, was killed while tending to the wounded on the first day of the battle of Gettysburg on July 1, 1863.

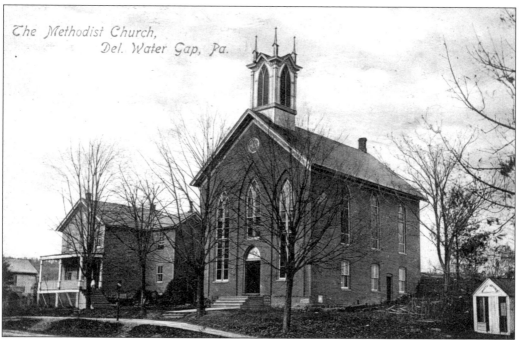

Established in 1870, the Methodist church was deconsecrated and closed in October 1992, after 122 years of continuous service. Fifty pastors had presided over the lifetime of the congregation.

Roman Catholics in Delaware Water Gap, Pennsylvania, worshipped at this small Mission Church of St. Mark's on Mountain Road. The church was closed in the 1970s and converted into cooperatives.

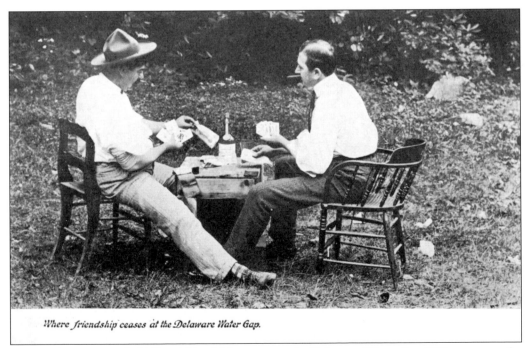

Where friendship ceases at the Delaware Water Gap.

This card is captioned, "Where friendship ceases at the Delaware Water Gap." The man on the left is identified as William Gibbs, part owner of both the Bellevue and Delawanna inns. The card sharp on the right is village barber Fred Kellerman.

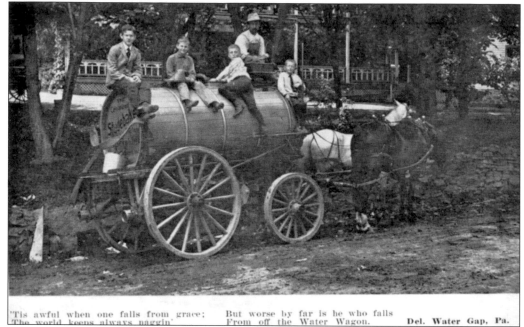

'Tis awful when one falls from grace; But worse by far is he who falls
The world keeps always naggin' From off the Water Wagon. **Del. Water Gap, Pa.**

Water wagons were essential in combating dust of the primitive country roads in 1902. The logo on the back of the tank reads, "the Celebrated Studebaker Water Sprinkler." Passengers, from left to right, are Arthur Shoemaker Jr., Mitchell Wallace, Stanley Hauser, Arthur Shoemaker Sr. (the driver and junior's father), and Rodney Brodhead.

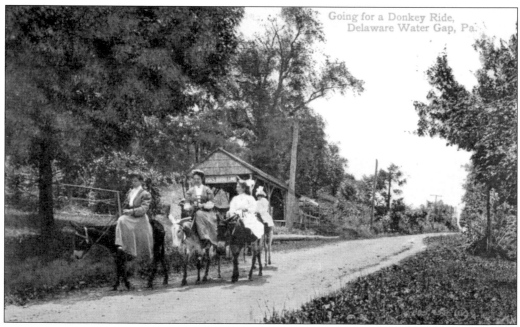

Going for a Donkey Ride,
Delaware Water Gap, Pa.

Burro rides were a popular activity for summer tourists, and hotels laid out trails to various attractions. Here four young ladies are setting out from Fox's Burro Stand to explore the wonders of the Delaware Water Gap.

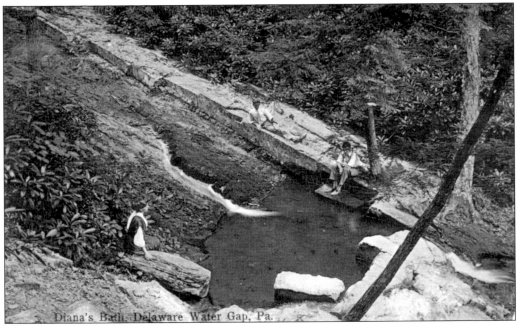

Diana's Bath, Delaware Water Gap, Pa.

Burro trails had to have destinations, and those with mystical names made ordinary places seem extraordinary. Diana's Bath (above) and Moss Grotto (below) were two examples located just above Caldeno Falls off a path named Sylvan Way. Riders or hikers found a refreshing rest at these locations where hotel owners erected rustic stairways and gazebos to add to their enjoyment.

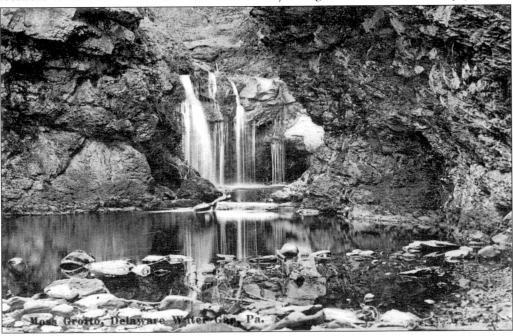

Moss Grotto, Delaware Water Gap, Pa.

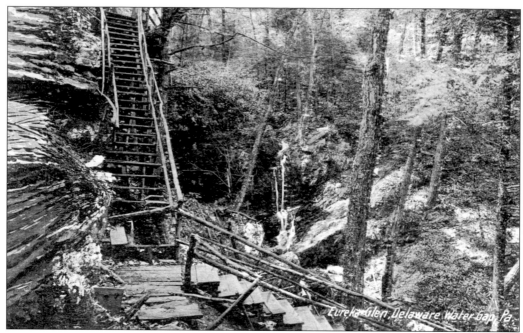

Eureka Glen (above) and Childs' Arbor (below) were two more points of interest. The glen lies on the eastern slope of Mount Minsi just off a trail called the Mountain Path. Eureka Creek flowed through the glen, tumbled over Eureka Falls, and reached the main road by Childs' Arbor. This attraction, which included a gazebo observation platform and a refreshment stand, was named for owner George Childs. Although the structures are long gone, Eureka Creek still flows down to Route 611 here and creates quite a cascade in the rainy season.

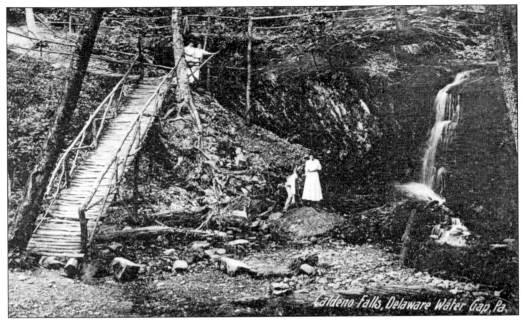

Caldeno Creek flows down the northeast slope of Mount Minsi and tumbles over the falls just below Diana's Bath. It is the water source for Lake Lenape, which lies on the former property of the Kittatinny Hotel, providing guests with a tranquil area for canoeing. The overflow from the lake was channeled directly through the kitchen of the hotel, functioning as its main water source.

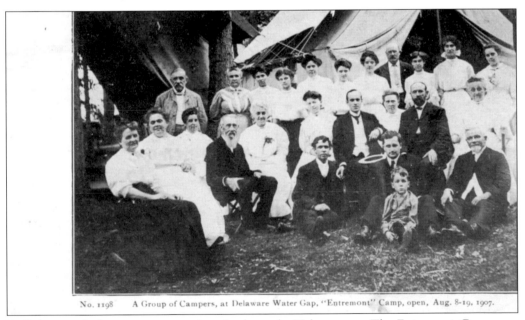

No. 1198 A Group of Campers, at Delaware Water Gap, "Entremont" Camp, open, Aug. 8-19, 1907.

Religious revivals were commonplace in the early 20th century. The Entremont Camp was held at Delaware Water Gap from August 8 to 19, 1907, and New York newspapers reported huge crowds that were thrilled by the week's speakers, including the Reverend Dr. P. J. Kain; William Thomas, the singing evangelist; and Mrs. Moore, the Maryland worker. Over 30 tents were erected on the meeting grounds, and the hotels were filled to capacity. The weather was described as ideal.

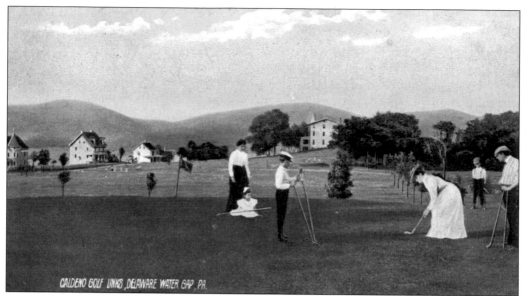

Golf was becoming popular, and hotel owners promoted the construction of local courses. Caldeno Links, designed by industrialist Charles C. Worthington in 1897, was built within the city limits. Caldeno was not a Native American name but rather a combination of surnames of the three men credited with discovering the source of the creek that feeds Lake Lenape: Pascal (cal), Ogden (den), and McLeod (o). The links closed shortly before World War I. The building in the rear center is the Oaks, and the houses at left stand on Shepard Avenue.

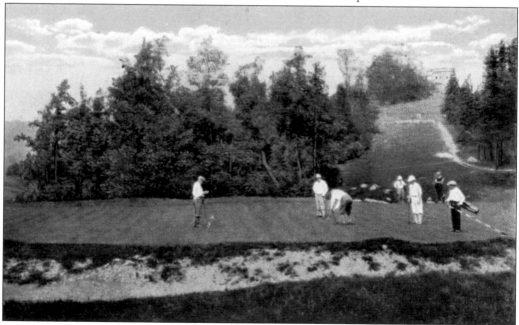

The Foley and Sullivan families, who built and operated the Reenleigh Hotel, recognized the need to replace Caldeno and built a nine-hole course on their property in 1922. Other hotel owners then contributed funds to purchase additional property on the opposite side of Tott's Gap Road to expand it to 18 holes, and it became the Wolf Hollow Country Club, surviving today as the Water Gap Country Club.

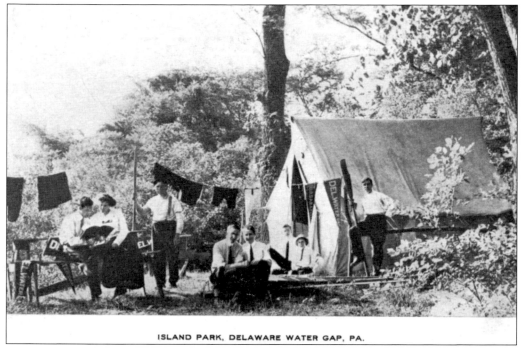

ISLAND PARK, DELAWARE WATER GAP, PA.

Another attraction created for visitors to the Delaware Water Gap was Island Park. Campers had been utilizing the site on Shellenberger's Island just north of the Lackawanna depot for years. Newspaper articles from 1906 report festivities on the island that included campfires, the telling of jokes, singing of ethnic songs, refreshments, and marshmallow toasting. In 1914, the Shellenberger brothers added an amusement park with a carousel, a roller rink, a shooting gallery, bathhouses, new boats, and a footbridge leading to the island from just north of the railroad station.

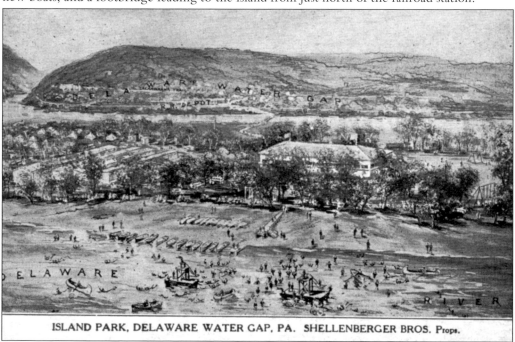

ISLAND PARK, DELAWARE WATER GAP, PA. SHELLENBERGER BROS. Props.

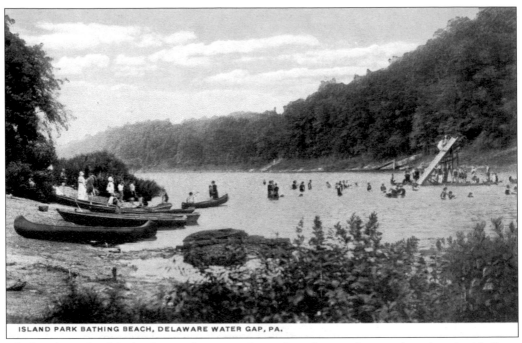

ISLAND PARK BATHING BEACH, DELAWARE WATER GAP, PA.

The beach at Island Park, shown above, was located on the east shore and equipped with floats and slides, much to the delight of visitors. Below, the new bathhouses can be seen at left, and the hot dog stand looks incredibly inviting.

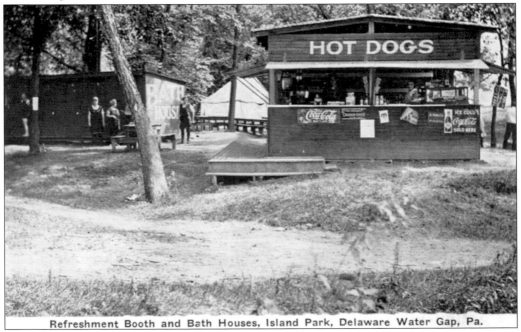

Refreshment Booth and Bath Houses, Island Park, Delaware Water Gap, Pa.

Seven

THE GRAND LADIES
THE PRESTIGE HOTELS

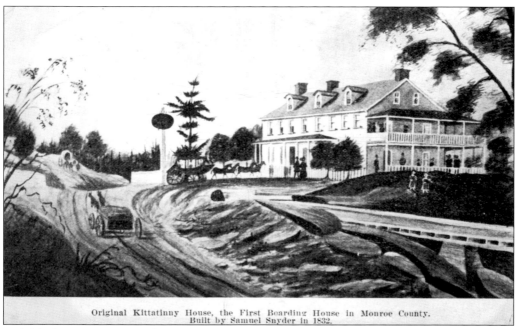

Original Kittatinny House, the First Boarding House in Monroe County.
Built by Samuel Snyder in 1832.

In 1793, Antoine Dutot, a plantation owner in Santo Domingo, fled the slave uprising there that eventually established the Republic of Haiti. Dutot arrived in Philadelphia and soon purchased a large tract of land in the Delaware Water Gap area and began the construction of a city called Dutotsburg, the forerunner of today's Delaware Water Gap, Pennsylvania. Recognizing the health benefits and natural beauty of the region, travelers began frequenting the community, boarding with local residents. Seeing potential in the hotel business, in 1829, Dutot began the construction of a small inn overlooking the Delaware River south of the village along a road that he had built to his sawmill. By 1832, he ran out of money and sold the partially finished structure to Samuel Snyder. The following year, Snyder completed the hotel and opened for business as the Kittatinny House.

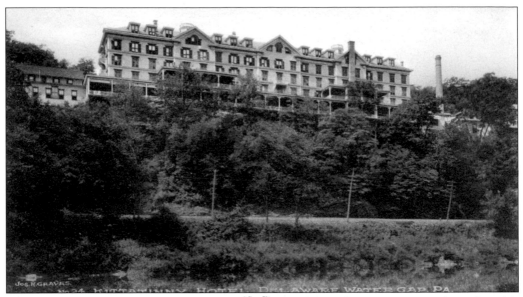

The Brodhead family rented the Kittatinny House, shown above, in 1841 and purchased it 10 years later. Under their stewardship, the building was expanded five times, until, by 1874, it could hold 275 visitors. By that time, the popularity of the Delaware Water Gap as a resort was spreading, and improved transportation was bringing tourists to the area by the thousands. In 1892, the building was razed to make way for a larger and more luxurious Kittatinny that could accommodate 500 guests. This was the Kittatinny best remembered in the postcards and view books and was the premier hotel of the Delaware Water Gap. In this unusual 1911 advertising postcard, shown below, G. Frank Cope was the proprietor, and an enterprising artist has imaginatively moved the hotel a half mile nearer to Point of Gap, Pennsylvania.

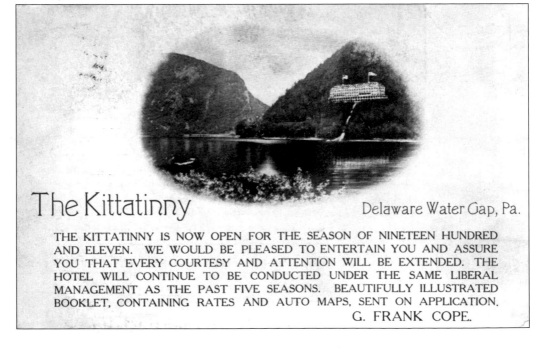

The Kittatinny Delaware Water Gap, Pa.

THE KITTATINNY IS NOW OPEN FOR THE SEASON OF NINETEEN HUNDRED AND ELEVEN. WE WOULD BE PLEASED TO ENTERTAIN YOU AND ASSURE YOU THAT EVERY COURTESY AND ATTENTION WILL BE EXTENDED. THE HOTEL WILL CONTINUE TO BE CONDUCTED UNDER THE SAME LIBERAL MANAGEMENT AS THE PAST FIVE SEASONS. BEAUTIFULLY ILLUSTRATED BOOKLET, CONTAINING RATES AND AUTO MAPS, SENT ON APPLICATION.
G. FRANK COPE.

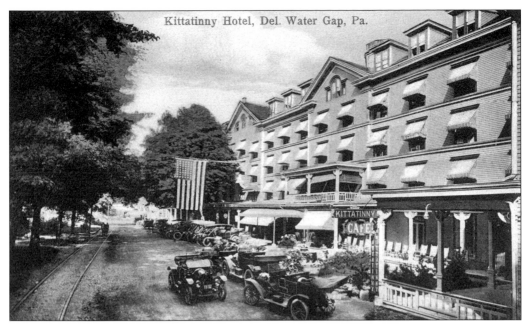

Kittatinny Hotel, Del. Water Gap, Pa.

Today's visitors to the Resort Point Overlook must wonder how the giant hotel could have fit on this small piece of land. The answer was simple—it was long and narrow. Here is the four-story (plus the attic, where servants were presumably housed) Kittatinny House in 1920, fronting on today's Route 611. The tracks at the left belong to the Stroudsburg, Water Gap and Portland Railway.

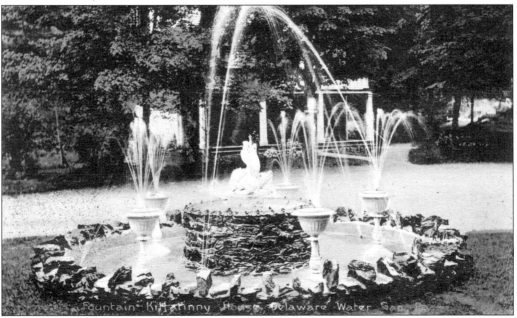

The Kittatinny House was noted for its 300-acre park, gardens, electric fountains, and woodland paths. The base of this fountain still can be found at the Resort Point Overlook, although the superstructure with its massive urns and stylized dolphin is long gone. In 1903, room rates were $15 to $30 per week, making it the most expensive lodging in town. By 1915, rates were "furnished upon request," and had probably hit $40 per week for first-class accommodations.

Sculptured grounds provided shady nooks for guests who might choose either to just relax or to take the rustic path down to the footbridge over the Lackawanna Railroad tracks that led to the boat dock on the river. Crossing the highway, visitors could follow the steps up along Caldeno Creek that led to Lake Lenape.

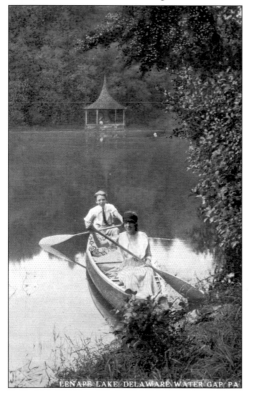

In the summer of 1913, a 14-year-old Fred Astaire and his 17-year-old sister, Adele, enjoy a canoe ride on Lake Lenape. Fred was a frequent visitor, and Adele was his first dancing partner. Fred lost his partner in 1932 when Adele married, but he went on to Hollywood to become a major star.

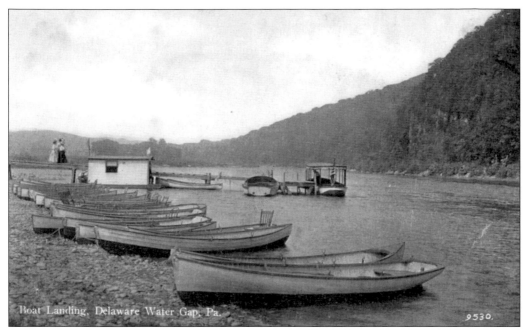

A walk down the Kittatinny House's river path and over a small bridge eventually brought guests to the dock and boat launch on a small island in the Delaware River. Here one might swim, rent a rowboat, or take a ride on the Kittatinny's launch, appropriately named the *Kittatinny*.

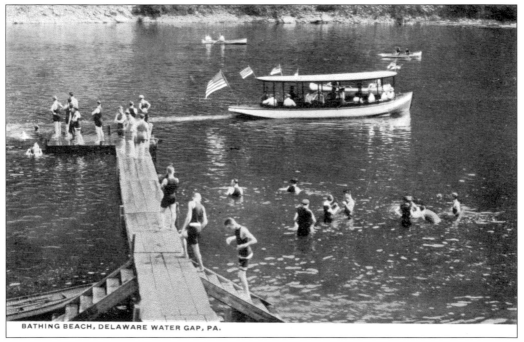

A group of bathers frolic at the dock, while the *Kittatinny* departs north toward Point of Gap, Pennsylvania. Passengers might either be on a river cruise or headed for a swim at Kittatinny Point in New Jersey, where a sandy beach awaited. Moonlight cruises were also a popular staple of river recreation.

The Kittatinny House boasted a full-length wraparound veranda on the first floor and smaller private porches on the second, totaling 20,000 square feet of space. Wicker-back rocking chairs provided guests the opportunity to relax while enjoying breathtaking views. The hotel was equipped with steam heat and elevators and boasted telephone service and a telegraph office on the premises.

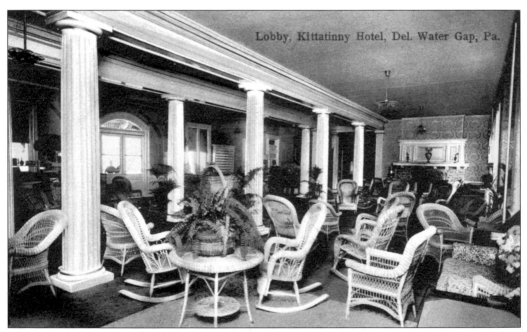

The lobby of the Kittatinny clearly demonstrates the long, narrow floor plan. The columns probably mark the position of the center hallways on the upper floors. The hotel boasted that its location took advantage of natural air conditioning provided by the breezes flowing through the gap. The hotel maintained its own dairy and greenhouse to provide table fare par excellence.

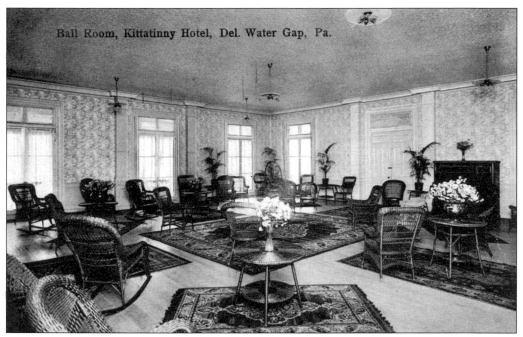

The ballroom hosted daily orchestral concerts and dances, as the furniture was easily cleared away to create a large multipurpose space. Other activities offered by the hotel included golf, tennis, bowling, billiards, pool, shuffleboard, fishing, horseback riding, and automobiling.

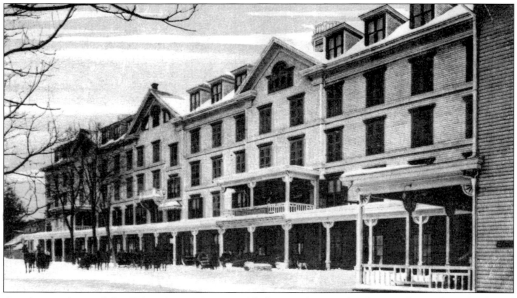

A winter view of the Kittatinny House with horse-drawn sleighs confirms that the hotel was occasionally open year-round, although it was typically operated only from April 1 to November 1. On October 30, 1931, owner John Purdy Cope and his family were awakened at 4:00 a.m. by a passing motorist who saw flames shooting from the building. Within a few hours, the grand lady was leveled for a total loss estimated between $500,000 and $750,000. With the Great Depression at its height and automobiles siphoning off vacationers to more distant places, it was not rebuilt.

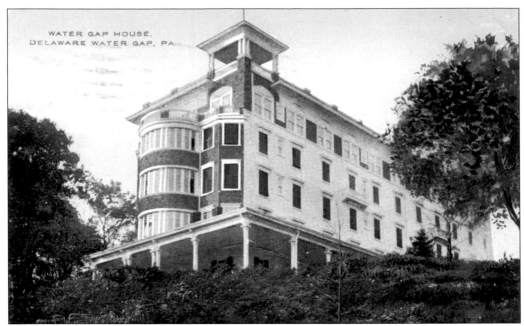

Designed to rival the Kittatinny House in luxury and appointments, the Water Gap House opened on June 20, 1872, and was operated by Luke W. Brodhead, former owner of the Kittatinny. It was located above the Kittatinny on Sunset Hill, which commanded a wonderful view of the Delaware River valley in both directions. Brodhead died on May 7, 1902, and the hotel was sold to John Purdy Cope. Weekly rates were $16 to $25.

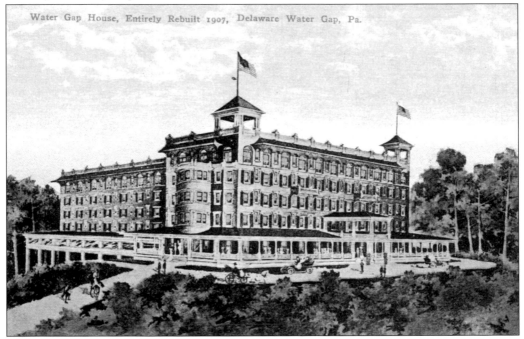

Under Cope's tutelage, the Water Gap House underwent a major renovation and addition after the 1907 season at a cost of over $100,000. By 1915, its last season, the hotel was touted as having a capacity of 500 and was to be open from May to December.

The Water Gap House advertised parklike grounds, a dry climate, and a great profusion of wild and cultivated flowers. This attractive main driveway led up a slight hill from today's Lake Drive to the porte cochere at the front entrance. Walking up the overgrown path today, it is hard to imagine that this grand lady ever even existed were it not for the postcard views and picture books as evidence.

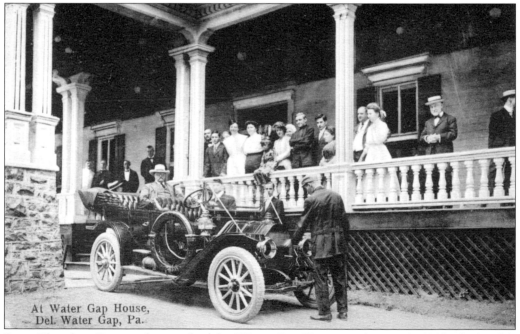

At Water Gap House, Del. Water Gap, Pa.

Pres. Theodore Roosevelt stayed at the Water Gap House on August 2, 1910, during his cross-country excursion. He had crossed the Delaware River at Myer's Ferry in Delaware, New Jersey, earlier in the day. Roosevelt raved about the grandeur of the area, remarking about how close it was to the population centers of the east and no doubt giving it wonderful publicity.

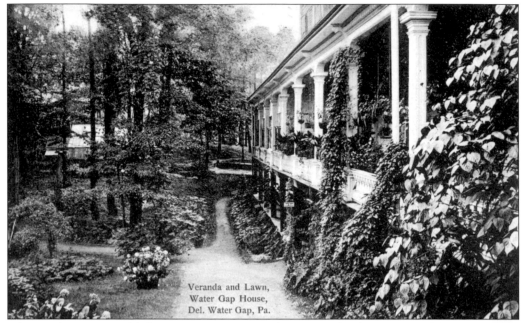

Veranda and Lawn,
Water Gap House,
Del. Water Gap, Pa.

John Purdy Cope touted the property at the top of Sunset Hill to be "devoid of fog, mosquitoes and humidity," as well as being remote from the noise and dust of the roads, railroad, and trolley line. The hotel was appointed with 100 tiled baths, elevators, electric lights, steam heat, log fires, and sun parlors on every floor. Like the Kittatinny House, the Water Gap House advertised its own dairy, greenhouse, and farm to provide unexcelled table fare.

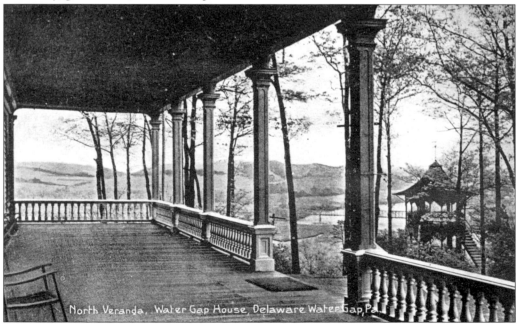

North Veranda, Water Gap House, Delaware Water Gap, Pa.

The view upriver from the eastern veranda was unexcelled. The rustic wooden gazebo at the point overlooking the river gave patrons an even closer view. One can imagine the beauty of this place when the rhododendron, azaleas, and mountain laurel were in bloom, not to mention the flaming fall foliage of Octobers past.

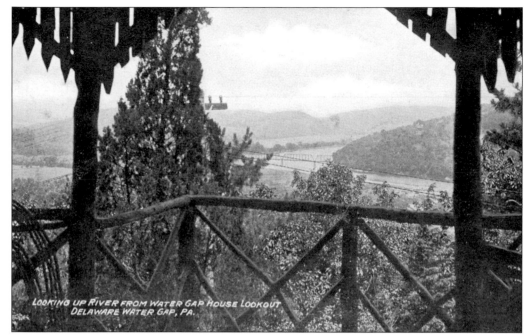

From the gazebo, one can enjoy a 10-mile view north up the Delaware River. Partially obscured by the power line, the Susquehanna bridge crosses the Delaware River from Karamac in New Jersey to North Water Gap in Pennsylvania. An altitude of 300 feet above the river gave the Water Gap House a decided advantage in the scenery department.

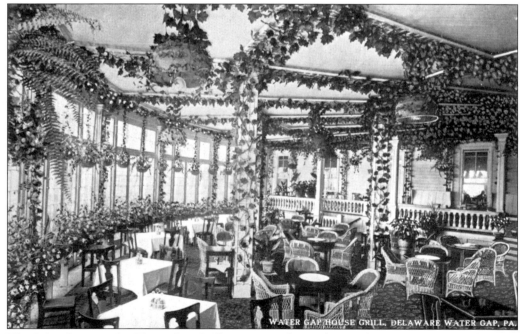

The Palm Court at the Water Gap Grill was a new dining feature for 1915. French chefs served a cuisine that was described as metropolitan. Fine food was an essential element in all of the many hotels and boardinghouses that dotted the Delaware Water Gap, as it was a primary factor in keeping customers satisfied and bringing them back year after year.

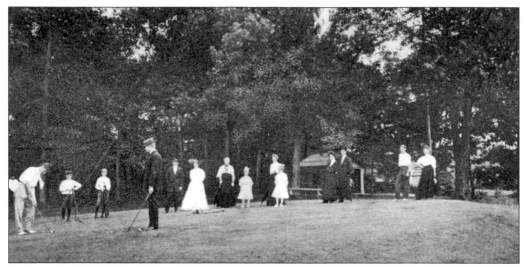

While it appears that the Water Gap House had a putting green, serious golfers played at the Caldeno Links, which lay within walking distance. On November 11, 1915, the hotel's legacy ended in a spectacular fire, which was discovered in a guest room by workmen closing the hotel for the winter. Within hours, John Purdy Cope's investment was gone. Although he promised to open a more luxurious hotel the following year, it was not to be. Perhaps the ledgers of the Water Gap House and Kittatinny, both of which Cope owned, already obviated the need for another building. Within a year, Caldeno was also just a memory, and houses occupy the property today.

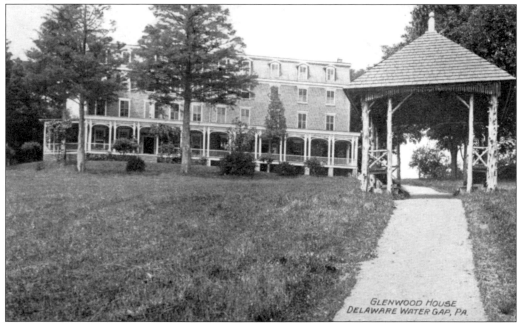

GLENWOOD HOUSE
DELAWARE WATER GAP, PA.

The Glenwood House began as a Presbyterian boy's academy in 1855, with the Reverend Horatio S. Howell, pastor of the Presbyterian Church of the Mountain, serving as principal. When Howell was killed at the Battle of Gettysburg, the school passed to his assistant, Samuel Alsop, who converted it into the hotel about 1864. The Glenwood House is the last of the old resort hotels to survive today.

Like the other major hotels, the Glenwood House boasted acres of shaded and well-manicured park grounds that extended down to Cherry Creek. P. R. Johnson was the proprietor in 1903 and could accommodate 250 guests at rates of $9 to $14 per week. By 1915, the hotel was expanded to house 400 and had increased its rates to $12 to $21 per week.

Rustic paths, a summer house, and a pavilion were features of the Glenwood House's 17 acres. The main dining room offered vegetables and fruits raised on a farm at the rear of the property. By 1915, the hotel had acquired the Del-Ray at the corner of Main and Broad Streets and renamed it the Glenwood Annex. Guests who stayed at the annex enjoyed "all hotel privileges," walking up to the main dining room for their meals.

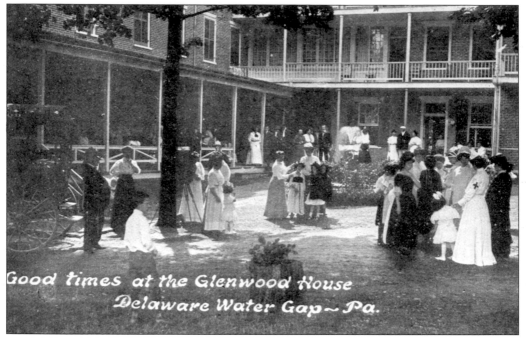

Good times at the Glenwood House
Delaware Water Gap~Pa.

Dances, concerts, and cakewalks were typical fare at the Delaware Water Gap hotels, and the Glenwood House was no exception. It advertised a "new ball room with a good orchestra." The survival of the hotel into the 20th century is easily explained by its brick construction as opposed to the wooden buildings that fell victim to fire.

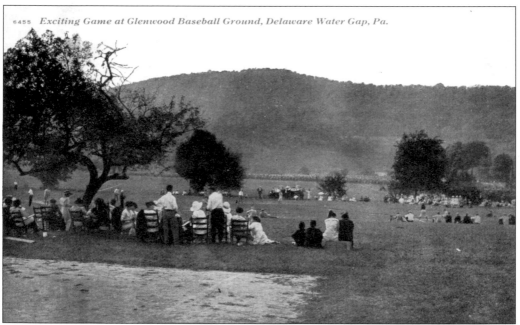

6455 *Exciting Game at Glenwood Baseball Ground, Delaware Water Gap, Pa.*

Baseball was becoming a popular sport by the 20th century, and the Glenwood House offered a fine playing field that delighted players and spectators alike. The hotel also offered tennis on two regulation-size clay courts, croquet, billiards, pool, and shuffleboard.

Eight

THE LITTLE SISTERS
LODGING FOR THE MASSES

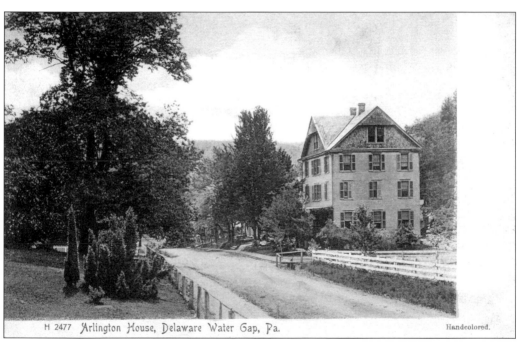

H 2477 Arlington House, Delaware Water Gap, Pa. Handcolored.

By 1867, additional lodgings had opened their doors in the hope of securing a share of the burgeoning tourism. Some were small hotels, some were boardinghouses, and some were simply farms that entertained guests in a bed-and-breakfast atmosphere. Some lasted briefly, and some changed their names several times. An example of the latter was Arlington House, which began its career after the Civil War as the Juniper Grove and later changed its name again in the early 1900s to the Bellevue House. The hotel accommodated 150 and was located on the south side of Delaware Avenue. Eugene Conway and Harvey Blair managed the Bellevue House, and the weekly rate in 1915 was $10 to $15.

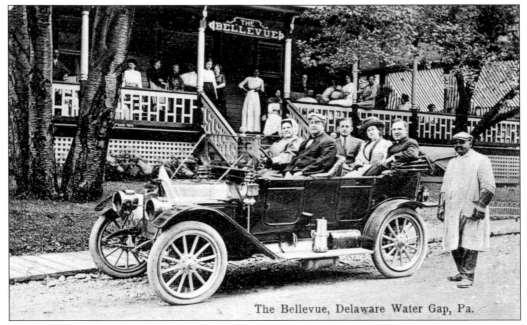

The Bellevue, Delaware Water Gap, Pa.

Automobiling was offered by many of the Delaware Water Gap hotels, and this group of guests from the Bellevue House seems eager to get under way. The horseless carriage was still a novelty for many in 1910, and a ride through the country was an adventure.

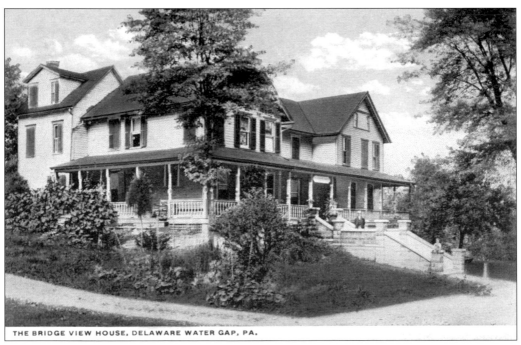

THE BRIDGE VIEW HOUSE, DELAWARE WATER GAP, PA.

The Bridge View House sat on Mountain Road and was managed by Grant Edinger. It operated May 1 through mid-November, advertised itself as a "pleasant home," and charged rates of $8 to $12 per week in 1915. Like many of the other hotels in the gap, the Bridge View House had an attached garden to supply fruits and vegetables.

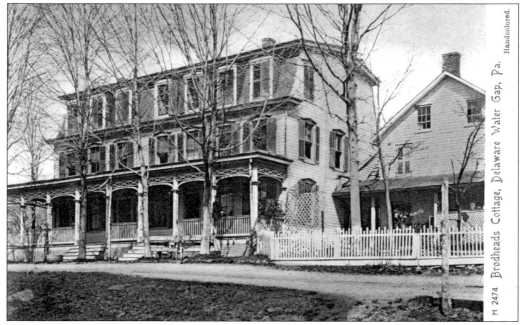

Abram Bush was the proprietor of Brodhead's Cottage in 1903, which accommodated 30 guests at rates of $8 to $10 per week. It was touted as a "charming summer home" with an "ample table" and was open from May 1 to November 1. It was located on Main Street near Cherry Valley Road.

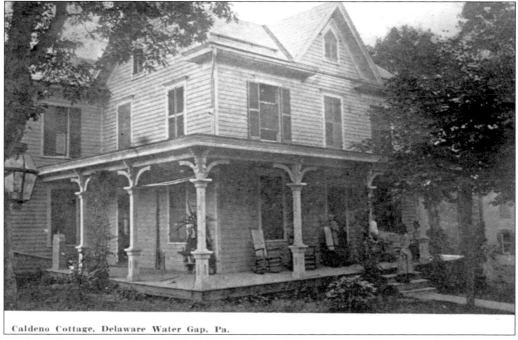

Caldeno Cottage, Delaware Water Gap, Pa.

Caldeno Cottage stood on today's Lake Road near Lake Lenape and was owned and managed by Frank Edinger. It described itself in a publicity pamphlet as "A Celebrated Resort Among the Blue Ridge Mountains." Caldeno Cottage accommodated 25 guests at $8 to $10 per week in 1915 and touted its "high elevation" as a health benefit.

The Castle Inn was built in 1906 by Dimmick D. Drake in Delaware Water Gap, Pennsylvania. In 1909, Drake added a 5,000-square-foot music hall containing a stage and balcony, which could hold several thousand people for concerts and dances. On August 20, 1912, John Philip Sousa and his band played there to a crowd of 875. Noted band leader Fred Waring purchased the inn in 1953 and headquartered his music business in the structure at the corner of Delaware Avenue and today's Waring Drive. The music hall was destroyed in a fire on March 29, 1985, but the hotel building still remains.

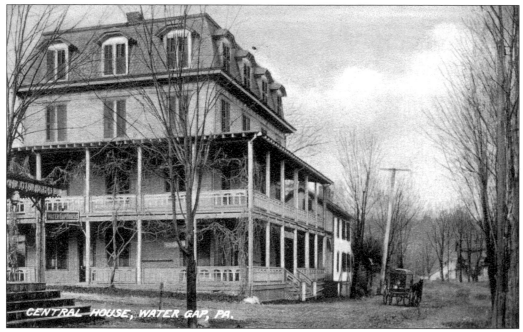

The Central House survives today as the Deer Head Inn, a restaurant and bed-and-breakfast, which is notably the home of Delaware Water Gap jazz music. H. T. Labar was the proprietor in 1915. It could accommodate 100 guests at $10 to $21 per week and was open seasonally from May 1 to October 15.

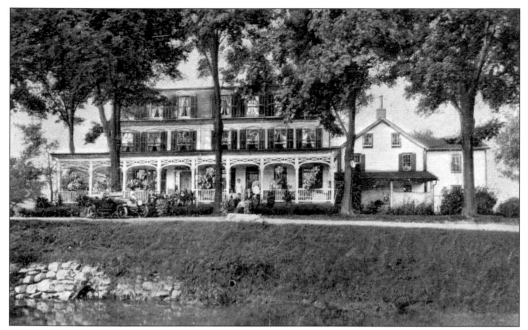

Courtenay Lodge was named for its proprietor, Harold Courtenay, and was situated on the banks of Cherry Creek just off Broad Street. It was open all year and charged rates of $8 and up per week. The lodge was fully equipped with "electric lights, baths, and sanitary arrangements." Its spacious verandas are evident in the photograph, which also shows the creek in the foreground.

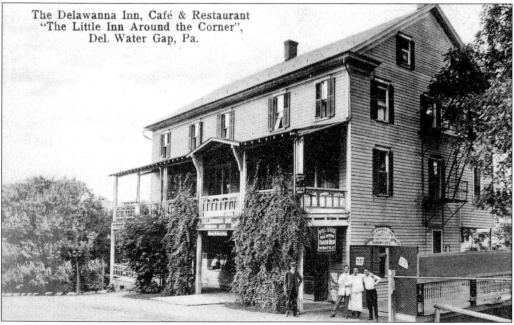

The Delawanna Inn stood on today's Route 611 just south of Delaware Water Gap and was also managed by Eugene Conway and Harvey Blair, the same duo that operated the Bellevue House. Rates in 1915 were $10 per week, and the Delawanna Inn was open all year, catering to "early spring or late trolley tourists." The Delawanna Inn fell victim to land purchases by the federal government in 1968.

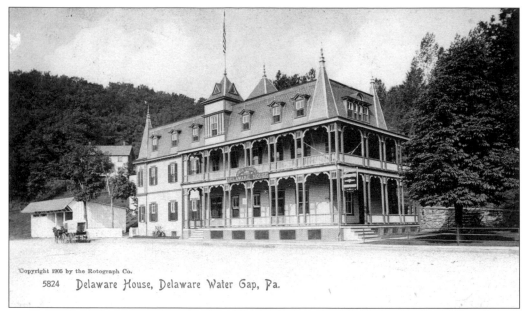

5824 Delaware House, Delaware Water Gap, Pa.

The Delaware House had the distinction of being the nearest hotel to the Lackawanna depot and needed only a porter to move its clients' luggage across the street. John Yarrick was the proprietor in 1903 and charged his 50 guests $10 to $14 per week. Its location doomed it to destruction in 1951 when the property was purchased by the Delaware River Joint Toll Bridge Commission for the construction of the new Delaware River bridge and toll plaza, and the building was demolished.

The Edgewood, E. E. Hoosier, Ownership Management, Del. Water Gap, Pa.

Clarence Newhart managed the Edgewood in 1915 and hosted 25 guests at rates of $8 to $12 per week. It was located on Minsi Road just in front of the Caldeno Links and was open seasonally from May to November.

The Edgewood's capacity was later expanded, and its name changed to the New Edgewood Hotel. A rear view of the New Edgewood Hotel property shows the clay tennis courts with the Caldeno Links beyond. Today the property is a residential neighborhood with single-family homes.

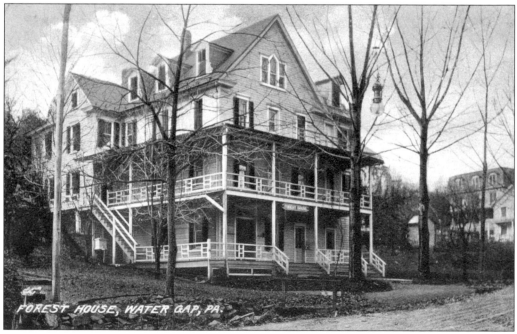

The Forest House stood on Delaware Avenue just up the hill from the Bellevue House. A. L. Marsh was the proprietor for over 30 years and rates were $8 to $10 per week in 1903 when the inn could accommodate 50. By 1933, the capacity was increased to 100, but the Depression-era rates had increased only $2.50 per week. The Forest House touted its close proximity to the town and its attractions.

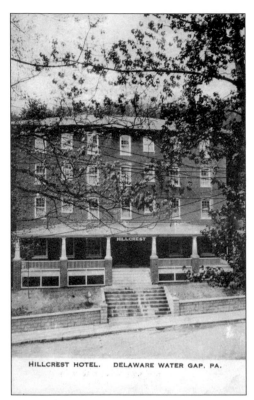

The Hillcrest sat near the foot of Delaware Avenue. Like its neighbor, it suffered the same fate at the hands of the Delaware River Joint Toll Bridge Commission, and its location now sleeps somewhere beneath the fill that supports the toll plaza on the west end of the Delaware River bridge on Interstate 80.

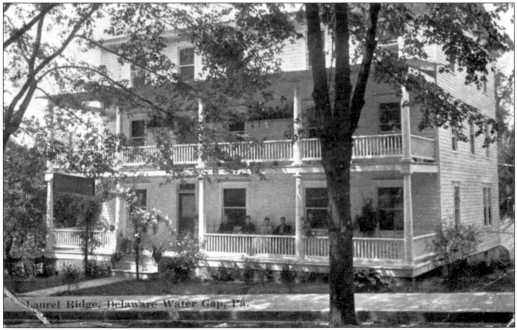

Laurel Ridge was located on Main Street and was owned and operated by Walter Shellenberger in 1915. It was advertised as a "new house with high elevation" with 25 guest rooms at rates of $8 to $10 per week. The note on the back of the card is interesting, as it is from Arminda Shellenberger to George Hester in Mount Bethel, asking about purchasing bushels of potatoes.

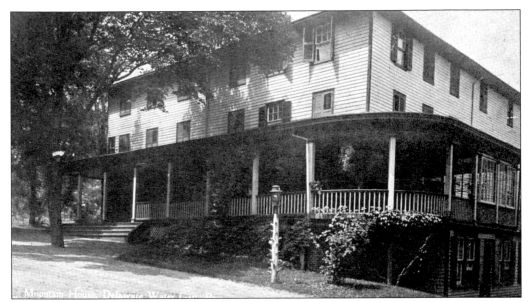

The Mountain House on Mountain Road was operated by Theodore Hauser. It did not accept guests until May 1 and had a capacity of 75 at rates of $10 to $14 per week. The business stayed in the family, as Mrs. Edward Hauser and her sons were the proprietors in 1933 and described it as the "Garden Spot of Delaware Water Gap." The Mountain House was one of the few Delaware Water Gap hotels to have a spring-fed swimming pool. Guests also enjoyed full privileges at Wolf Hollow Country Club.

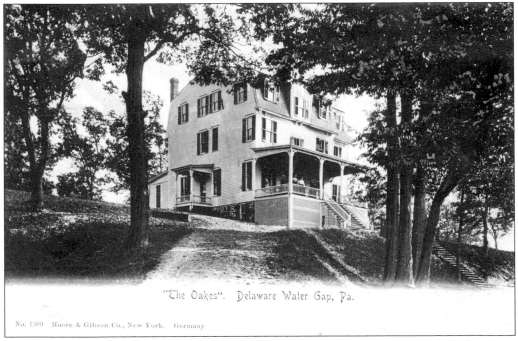

"The Oakes". Delaware Water Gap, Pa.

No. 1309 Moore & Gibson Co., New York. Germany

The Oaks (or Oakes) was located on Water Gap Heights at the northeast corner of Shepard Avenue and Minsi Road. Charles Barget was the owner in 1915 and rented rooms to 35 guests at the rate of $10 and up per week. The Oaks specialized in providing a German American table, notably the only hotel or boarding home in the area to do so.

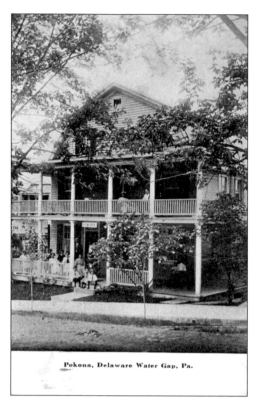

Pokona, Delaware Water Gap, Pa.

The Pokona was another Shellenberger family enterprise in town, this one operated by Herbert. Advertising a hillside location only one-sixth of a mile from the Lackawanna depot placed it near the center of town on Main Street. It was later known as the White Fawn Inn owned by O. Leland Bechtel. Rates were typical in 1915 at $10 to $15 per week.

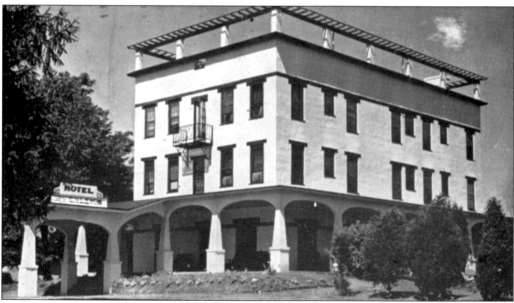

The Reenleigh, named for the county in Ireland from which the owners' ancestors came, was the last hotel to be built and was completed in 1920 by Robert Foley and his cousins the Sullivans. It stood on Dogwood Drive and featured a unique rooftop dining and dancing pavilion. In 1922, to fill the void caused by the loss of Caldeno Links, the Foleys added a nine-hole golf course, which eventually evolved into Wolf Hollow, the forerunner of today's Water Gap Country Club. In later years, the hotel was renamed Laurel Lodge. The building burned on October 30, 1979.

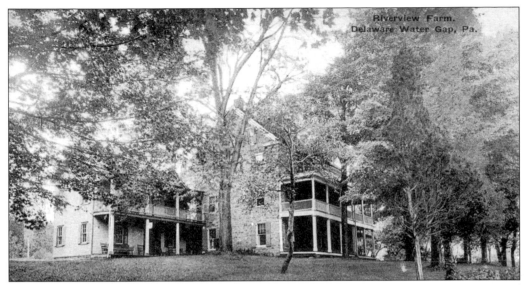

River View Farm or Croasdale Manor was located on the old stage road between Easton and Stroudsburg, Pennsylvania, and the main house stands along the south side of Interstate 80. The original inn was built in 1791 by Ulrick Hauser, who seemed to be something of an adversary to Antoine Dutot. The two quarreled frequently, probably over boundaries and such, the "war" ending with Dutot being indicted by a grand jury for assault and battery on Hauser. The 200-acre farm could accommodate up to 65 guests by 1933. The inn burned in 1939 but was rebuilt in the 1950s by the Croasdale family.

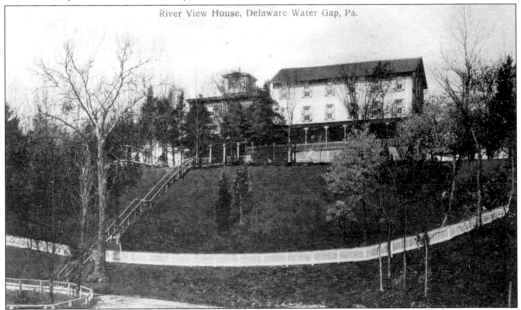

The River View House sat on a knoll overlooking the Delaware River just north of the Lackawanna depot. Lizzie T. LaBarre was the proprietor in 1903 and charged visitors $7 to $10 per week, although special rates were offered to seasonal guests. The hotel could accommodate between 100 and 150 guests during its career and was operated by LaBarre's estate long after her passing. Much of the property was taken for the construction of the Delaware River bridge and toll plaza in 1951.

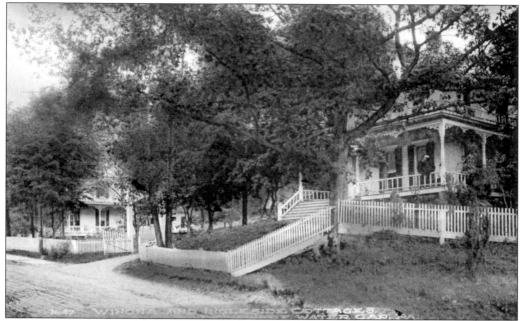

The Winona and Ingleside cottages were typical of small boardinghouses in Delaware Water Gap, Pennsylvania, that flourished from the Victorian age until the 1920s. The coming of the automobile changed the face of family summer excursions for good, as people began traveling greater distances on better roads and staying only for a night or two in one place.

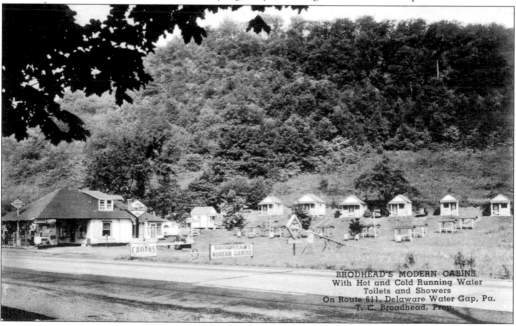

BRODHEAD'S MODERN CABINS
With Hot and Cold Running Water
Toilets and Showers
On Route 611, Delaware Water Gap, Pa.
T. C. Broadhead, Prop.

Places like Brodhead's Modern Cabins on Route 611 just north of the village innocently contributed to the demise of the resort hotels. As pioneers of today's vast network of motor hotels or motel lodging facilities, they catered to the transient families who were not afraid to spend time on the road in their "modern Conestogas" to cram in as many sights as possible during their short summer vacation.

Nine

North Water Gap and Shawnee
Water Cures and Golf

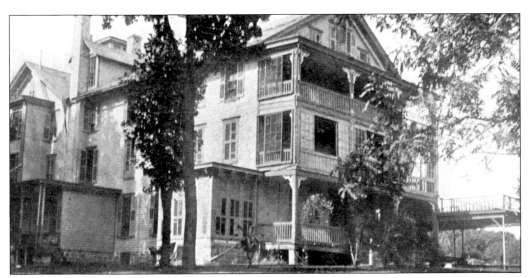

At the time the first post office was opened in 1829, the small village along Brodhead's Creek was known as Experiment Mills, Pennsylvania, named for the new methods of flour production developed along the waterway. In 1873, Dr. F. Wilson Hurd brought the Wesley Water Cure to the area and built his Water Cure of Experiment Mills near the mouth of the creek. The cure, developed in 1749 by the Reverend John Wesley, founder of the Methodist Church in America and also a noted physician, utilized immersion in cold water baths at regular intervals as a method of treating 80 specific diseases. Hurd found the fresh, crisp water of Brodhead's ideal for his purposes. The institution eventually became the Water Gap Sanitarium. Apparently the water cure was not useful in treating tuberculosis, as early advertising cards indicated that "consumptives [were] not welcome."

White settlers occupied the valley of Brodhead's Creek in the 1500s, but it was not until the 1800s that the area saw development. Sheep ranching and lumbering were early occupations, naturally giving rise to woolen mills and sawmills. Experiment Mills, Pennsylvania, renamed North Water Gap in 1902, boasted a store, a post office, and the Minisink Hotel. The arrival of the Lackawanna Railroad at Delaware Water Gap in 1856 boosted the tourist trade, and the construction of the Susquehanna in 1882 gave North Water Gap its own depot. In 1931, the village changed its name to Minisink Hills.

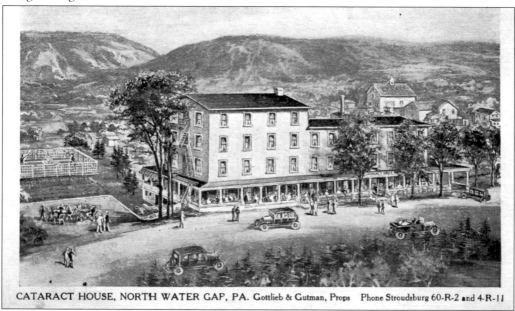

CATARACT HOUSE, NORTH WATER GAP, PA. Gottlieb & Gutman, Props Phone Stroudsburg 60-R-2 and 4-R-11

In 1903, the Cataract House, located on today's Route 209, could accommodate 100 guests. By 1915, its capacity had been increased to 200. Garrett R. Tucker was the owner-manager and advertised well-shaded lawns, suites, hot and cold running water in rooms, pool, billiards, bowling, tennis, weekly regattas, and more. It was later known as the Lakeview.

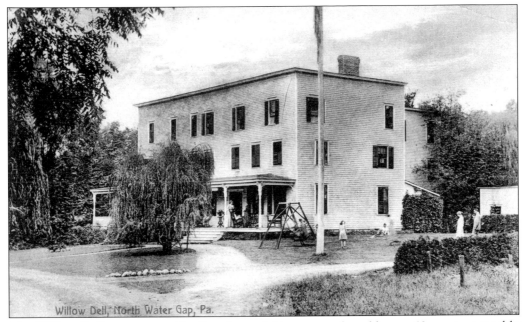

The Willow Dell was operated by Seguine and Altemose and could serve 60 guests at weekly rates of $9 to $14 in 1915. It was located at Buttermilk Falls adjacent to Silver Lake. Those who desired the "outdoor life" could rent a tent and camp on the grounds, still enjoying full privileges in the dining room and recreational facilities. While most boarding facilities enjoyed electric lighting, the Willow Dell used acetylene. The building survives today as the Shawnee Realty Office and Welcome Center.

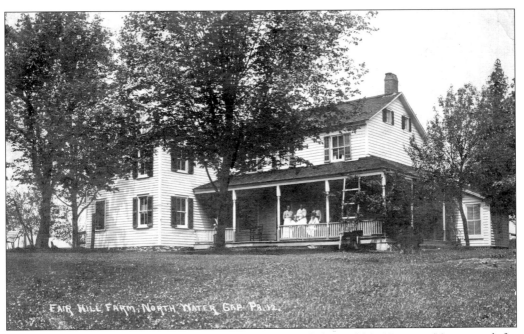

Lewis Overfield operated the Fair Hill Farm in 1903 and charged his 25 guests $8 per week for bed and board. The facility was open from June to October and typified the "boarding farm" type of vacation retreat, which mirrors today's popular bed-and-breakfasts.

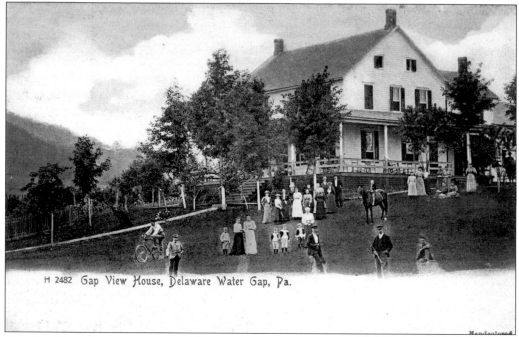

H 2482 Gap View House, Delaware Water Gap, Pa.

The Gap View House was operated by Samuel Overfield and was located on 35 acres of farmland on Shawnee Mountain. Its 70 guests paid $8 to $12 per week to sample its "magnificent views of the Delaware Valley."

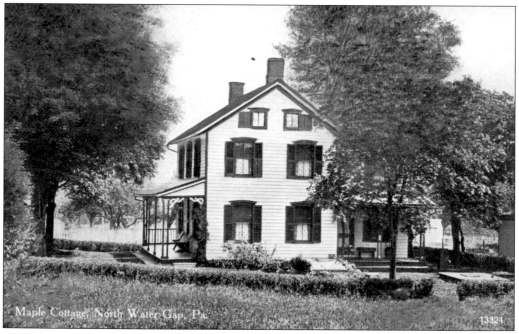

Maple Cottage, North Water Gap, Pa.

H. Y. Ace was the proprietor of Maple Cottage in 1933 and touted the "grand old maples" that surrounded the house and provided both shade and a trademark. Table fare, in the form of vegetables, eggs, milk, and poultry, was supplied from the inn's farm. The phone exchange was Stroudsburg 76–R–21.

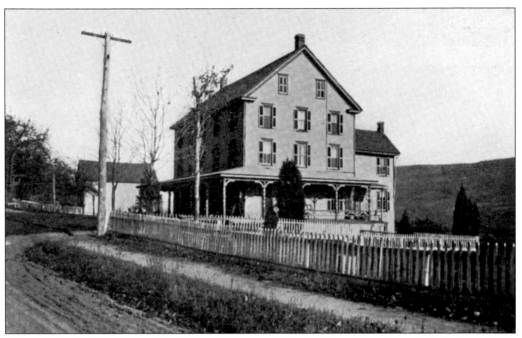

The Ace family also operated the Riverside House in North Water Gap, Pennsylvania, shown here about 1910. From a capacity of 50 in 1903, an entire wing was added that increased the number of guests to 100 by 1915. Rates at that time were a competitive $8 to $12 per week. Like the Willow Dell, the Riverside House also employed the use of acetylene for lighting purposes.

Buttermilk Falls, North Delaware Water Gap, Pa.

Buttermilk Falls are formed as Marshalls Creek tumbles down over the Oriskany Ridge toward a rendezvous with Brodhead's Creek and the Delaware River. The upper falls drop about 20 feet and the lower falls about 12 feet. While certainly not Niagara Falls, Victorian guests found the hike to the cool water refreshing on a hot summer day.

Hill's Baseball Diamond, North Water Gap, Pa. 13100

The pitcher is in his windup in this lively contest at Hill's Baseball Diamond in North Water Gap, Pennsylvania. The crowded grandstand is evidence of the popularity of "America's game" in the summer of 1913 when this card was sent. Mrs. Youmans, the sender, wrote, "This is my father's baseball diamond."

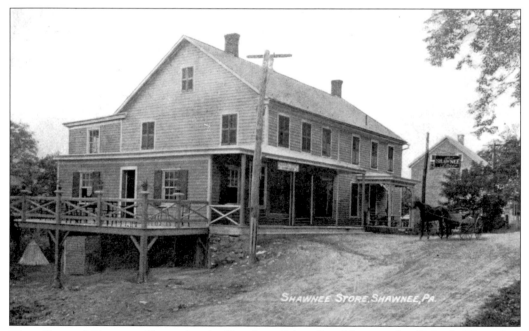

SHAWNEE STORE, SHAWNEE, PA.

The village of Shawnee, Pennsylvania, lies along River Road just north of North Water Gap (Minisink Hills). The general store looks much the same today as it did when this postcard view was taken about 1910. Shawnee was settled by Nicholas Depuy (or Dupui), a French Hugonot, who purchased 3,000 acres of land from the Minsi tribe in 1727.

Three local children stand in the middle of River Road in 1910 with little fear of even seeing an automobile. The general store is to the rear left, and the rough stone building at the right is the former Shawnee post office. Both survive today.

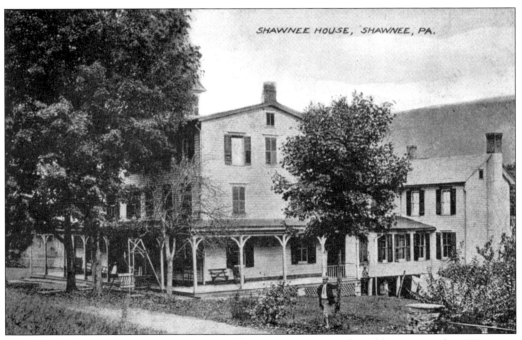

In 1903, the Shawnee House was operated by I. R. Transue and could accommodate 75 guests at rates of $6 to $10 per week. By 1915, W. T. Transue had reduced the capacity to 50 but raised the rates to $10 to $15 per week. The hotel was open from April 15 to December 15 and was noted for the attached 150 acre scientific farm, which provided milk, butter, vegetables, eggs, poultry, and fruit for the table.

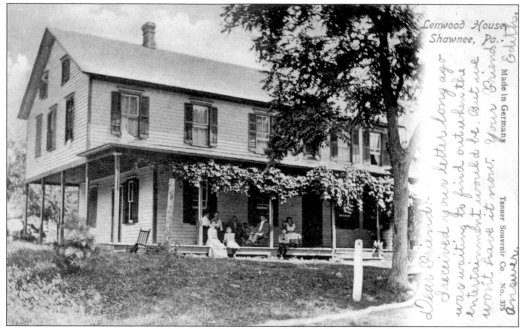

George Dietrich was the proprietor of the Lenwood in 1903 and hosted 30 guests at rates of $5 to $7 per week. He advertised a location "situated amongst beautiful mountain scenery three miles from the [railroad] station."

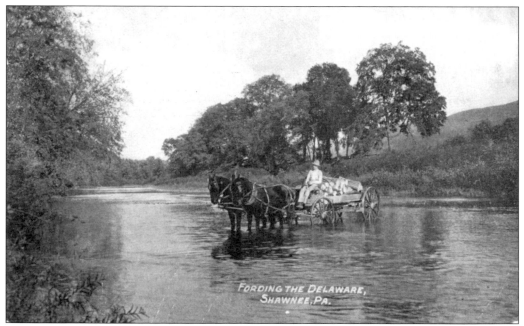

FORDING THE DELAWARE, SHAWNEE, PA.

A local farmer fords the Delaware River at low water with a load of firewood in this early view. During the dry season, the river was easily crossed by wagon at numerous locations, and local residents could thereby avoid paying the nominal ferry toll.

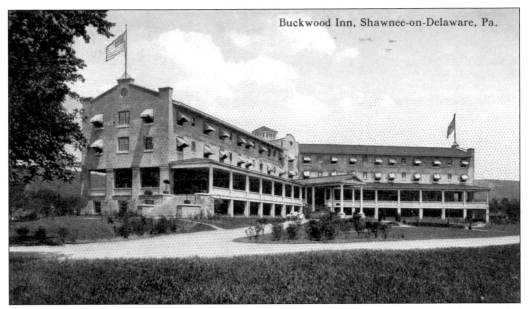

The Buckwood Inn was designed and built at Shawnee, Pennsylvania, by New York industrialist Charles C. Worthington, president of the Worthington Pump Company. It opened as a seasonal resort in May 1911 and was unique in that it was constructed of concrete, making it virtually fireproof. In 1943, Worthington sold the inn to bandleader Fred Waring who renamed the facility the Shawnee Inn and made it the headquarters of his musical empire. The inn is owned today by the Kirkwood family.

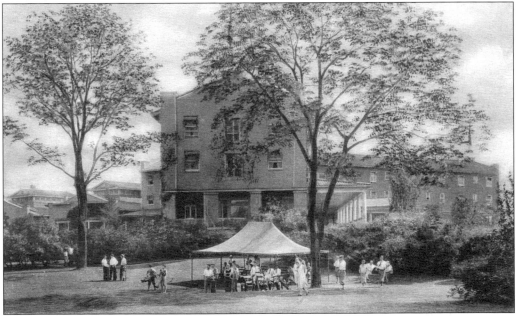

The star of the Buckwood Inn was its 18-hole golf course, built on neighboring Shawnee Island. Worthington commissioned novice designer A. W. Tillinghast to create the masterpiece. Tillinghast went on to design such courses as Baltusrol, Winged Foot, and Bethpage Black. Jackie Gleason learned to play golf here, and noted professional Arnold Palmer met his first wife at Shawnee. Perry Como, Lucille Ball, and Ed Sullivan were frequent guests.

A player hits out of the "punch bowl," one of the Buckwood Inn's more challenging holes, in the 1920s. The inn is rumored to have hosted one of the first meetings of the Professional Golfer's Association (PGA) and held the first Shawnee Open in 1912. In 1938, the course hosted the PGA championship, with Paul Runyan besting the Buckwood's touring professional Sam Snead eight and seven.

Charles C. Worthington also built Worthington Hall in 1904 as an entertainment venue. The local Shawnee Players performed here from 1904 until 1943, when Fred Waring bought the property and used the hall as a location for weekly radio broadcasts with his band, the Pennsylvanians. After Waring sold the inn, the hall fell into disrepair but was restored by the Kirkwoods. An arsonist destroyed the hall on June 24, 1985, but with a massive input of time and donations, it was rebuilt.

BIBLIOGRAPHY

Cummins, George Wyckoff. *History of Warren County, New Jersey*. New York: Lewis Historical Publishing Company, 1911.

Dale, Frank T. *Our Delaware River Ferries*. County Chronicles Series Monograph, 2002.

Delaware, Lackawanna and Western Railroad. *Mountain and Lake Resorts on the Lackawanna Railroad*. New York: Passenger Traffic Department, 1903, 1915, and 1933.

Freedman, Sally A. *Delaware Water Gap, the Stroudsburgs, and the Poconos*. Dover, NH: Arcadia Publishing, 1995.

Ketterer, Debby, and Martin Wilson, ed. *Delaware Water Gap, Then and Now*. Delaware Water Gap, PA: Debby Ketterer, 2001.

Lloyd, JoAn, and Eileen Kline. *Portland Area Centennial 1876–1976*. Portland, PA: Portland Centennial Book Committee, 1976.

Nagy, Patricia R., Maureen M. Mooney, and Lola C. Master. *Historical Sites of Knowlton Township*. Knowlton, NJ: Knowlton Bicentennial Book Committee, 1976.

Rohrbeck, Benson W. *Trolleys to the Delaware Water Gap*. West Chester, PA: Ben Rohrbeck Traction Publications, 1989.

Sweeney, Alan. *Journey Along the Delaware, Lackawanna and Western Railroad*. Eynon, PA: Tribute Books, 2007.

Taber, Thomas Townsend. *The Delaware, Lackawanna and Western Railroad in the Nineteenth Century*. Muncy, PA: Thomas T. Taber III, 1977.

Toth, Albert M. *Slate Belt Bicentennial Heritage*. Bangor, PA: Slate Belt Bicentennial Committee, 1976.

Warren County Tercentenary Committee. *Historical Sites of Warren County*. Belvidere, NJ: Warren County Board of Chosen Freeholders, 1965.

Wilson, Martin W., ed., and Francis (Casey) Drake. *Delaware Water Gap Bicentennial, 1993–A Treasury of Times Past*. Delaware Water Gap, PA: Antoine Dutot School and Museum, 1993.

ACROSS AMERICA, PEOPLE ARE DISCOVERING SOMETHING WONDERFUL. *THEIR HERITAGE.*

Arcadia Publishing is the leading local history publisher in the United States. With more than 3,000 titles in print and hundreds of new titles released every year, Arcadia has extensive specialized experience chronicling the history of communities and celebrating America's hidden stories, bringing to life the people, places, and events from the past. To discover the history of other communities across the nation, please visit:

www.arcadiapublishing.com

Customized search tools allow you to find regional history books about the town where you grew up, the cities where your friends and family live, the town where your parents met, or even that retirement spot you've been dreaming about.

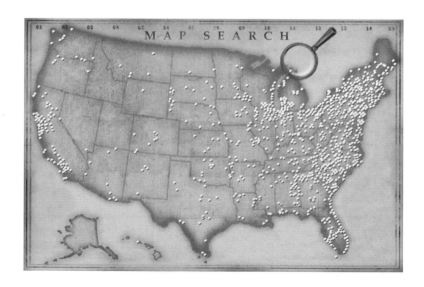